Van Gogh Drawings

For Professor J. G. van Gelder

Evert van Uitert

Van Gogh

Drawings

Thames and Hudson

Illustration on front: *Old Vineyard with Peasant Woman* (see colorplate IV)

Translated from the Dutch *Vincent van Gogh tekeningen* by Elizabeth Willems-Treeman

First published in Great Britain in 1979 by Thames and Hudson Ltd., London

Printed and bound in Yugoslavia

Contents

"In spite of everything I shall rise again: I will take up my pencil, which I have forsaken in my great discouragement, and I will go on with my drawing."
Vincent van Gogh, 24 September 1880 [136]

Throughout the text, the numbers in square brackets refer to the letters as so numbered in *The Complete Letters of Vincent van Gogh*, 3 vols, Thames and Hudson, London 1958, and New York Graphic Society, Greenwich, Connecticut, 1953.
In the listings accompanying the plates, the letters (F, SD) and numbers in parentheses correspond to those in J. B. de la Faille's œuvre catalogue of Van Gogh's paintings and drawings (see Select Bibliography).

Introduction

When Vincent van Gogh (1853-90) died he had, in approximately eight years, painted more than eight hundred canvases. How many drawings he had made, over a longer period, can never be known, for although over sixteen hundred still exist and have been catalogued, many hundreds more were lost or destroyed during his lifetime or shortly after. All that is left of them are mentions or descriptions in his letters.

Vincent's path to art was tortuous. After his failure as an art dealer, a career he tried to follow from 1869 to 1876, came a series of attempts to find his place in society in other ways. He was an assistant teacher in England, a clerk in a Dordrecht bookshop, a theological student in Amsterdam, and in 1878, after a crash course, a missionary in the sombre Belgian mining district, the Borinage. When this endeavor to make something of himself also failed, Vincent underwent a deep emotional crisis. Even his brother Theo, with whom he had begun to correspond as early as 1872, received no letters during the winter of 1880. Yet Vincent must then have made his decision to become an artist. From the end of 1880 he exerted all his strength to attain the goal he had set himself. Very soon he went to Brussels with the idea of studying drawing at the art academy, where instruction was free of charge. His career as an artist had definitely begun and was to last ten years.

The Novice Draftsman

To become an artist, Vincent followed the traditional path, which led from the copying of examples through working from plaster models to drawing directly from nature. Drawing served as a preparation for painting. Yet Vincent's drawings were never wholly subservient to his paintings. He had always liked to draw, even when he had as yet no thought of becoming an artist and despite the fact that, as Julius Meier Graefe put it, "the Graces were not in attendance around his cradle."[1]

1 Julius Meier-Graefe, *Vincent van Gogh der Zeichner*, Berlin 1928, page 14.

He drew as will nearly every child who gets the chance. No doubt his mother encouraged him, for she is known to have been fond of making colored drawings herself. At the age of nine Vincent was a fair copyist, as one of his rare childhood specimens shows (plate 1).

At the secondary school in Tilburg, which Vincent entered in 1867, he had lessons from the painter C. C. Huysmans, a champion of good training in drawing.[2] Huysmans stressed the development of artistic judgment. Because the level of the Dutch entries at the international exhibition in London in 1851 had been lamentably low, great efforts were being made – supported by the government – to improve the standard. Throughout Europe, indeed, instruction in drawing was considered one of the best methods for developing a feeling for art.

Vincent did well at school, especially in mathematics. In his first year, as was customary then, he had five hours of drawing instruction a week, the same amount of time that was spent respectively on French and English. Drawing lessons, however, were cut down in the second year, the last that Vincent completed. For some unknown reason, he had to break off his studies.

In his letters Vincent never refers to his first teacher, although he must have learned some of the elements of drawing and especially of copying from Huysmans. The training was too short or too superficial to include perspective, a lack that Vincent later deeply regretted.

A year after leaving school, when he was sixteen, Vincent started work in the art trade, as his brother Theo, four years his junior, was to do. Their choice of profession was quite natural, for three of their paternal uncles were art dealers, one in Rotterdam and Brussels, one in Amsterdam, and one in retirement from the Paris firm of Goupil & Co. The fourth, Vincent's namesake, was instrumental in securing employment for his nephew at Goupil's branch in The Hague. The firm dealt in contemporary paintings and prints and pioneered the use of photography as a good means of reproduction.

During his years with Goupil, which he served variously in The Hague, London, and Paris, Vincent learned much about art. To extend this knowledge, he visited museums. He also continued to draw (plate 2). It was probably in 1873 that he made three booklets illustrated mainly with animals, birds, and insects for Betsy Tersteeg, the little daughter of Goupil's manager in The Hague.[3]

2 H. F. J. M. van der Eerenbeemt, *De onbekende Vincent van Gogh: Leren en tekenen in Tilburg, 1866-1868*, Tilburg 1972.

3 Anna Szymańska, *Unbekannte Jugendzeichnungen Vincent van Goghs und das Schaffen des Künstlers in den Jahren 1870-1880*, Berlin 1967.

Later that year he was sent to work in the Goupil office in London, and from there he began his correspondence with Theo in earnest. In the summer of 1874 he wrote, "Lately I took up drawing again, but it did not amount to much" [17]. And a little later: "Since I have been back in England, my love for drawing has stopped, but perhaps I will take it up again some day or other. I am reading a great deal just now" [20]. Drawing (and, when the time came, painting) and reading – these were the activities that engrossed Vincent throughout his life.

In April 1875 Vincent sent Theo a landscape sketch of Streatham Common which he said he had been moved to make because of the death of his landlady's young daughter [25]. Emotional difficulties often led him to seek release in drawing. In other letters he sketched the places where he was staying, to refresh his own memory or to give Theo an idea of them.

The rooms Vincent occupied in London and Paris were adorned with prints he had collected. On the walls of his room in Montmartre, in 1875, hung twenty-three engravings, which he listed in two letters to Theo [30, 33]. They included many landscapes by painters of the Barbizon school or works of the same genre, and many religious subjects. Even at that time Vincent was an ardent collector of prints. His career in the art trade was not thriving, however, and Goupil's dismissed him as of the first of April 1876. Before leaving for England to take a new job as assistant teacher, one of the last things he did in Paris was to visit the Durand Ruel gallery, where he saw "more than twenty-five etchings after Millet, the same number after Michel, and a great number after Dupré and Corot. All the other artists can be purchased there at 1 franc apiece; it was tempting. I could not resist the Millets and bought the three last that were to be had after 'The Angelus'; of course, my brother will get one of them at the first opportunity" [58].

In England he showed the prints around at the school where he worked, not in the first place for aesthetic pleasure, but rather for the message they conveyed. Vincent was never to subordinate the literary content of art to form, color, or composition. He constantly resisted the idea of art for art's sake.

His prospects as assistant teacher were not promising. He liked to teach, but the business of collecting school fees, which took him to the poorest sections of London, was distasteful to him. At about this time he began to preach, and he became ever more religiously exalted. When Christmas came, he went home to Etten and never returned to England again.

New work was found for him in a bookshop in Dordrecht, where he remained until May 1877. While there he apparently acted at one time as go-between in the matter of some drawing material, for he wrote to Theo, then in The Hague, "Tell Mr Tersteeg not to be angry about our keeping the drawing exam-

ples so long. Thirty of them have already been bound for the high school, but they want to select some for the evening school too, and so we must keep them a few days longer" [85]. Whether he, too, was drawing from the examples he does not say, but it is unlikely, for he was still filled with his religious fervor. This and his desire to reinstate himself in his father's favor – his much-admired father, who was a Protestant minister in the predominantly Catholic province of North Brabant – led him to decide to enter the ministry himself.

In the spring of 1877, at the age of twenty-four, Vincent left Dordrecht for Amsterdam to begin the preparatory work for studying theology at the university there. At the outset he applied himself energetically to his Greek and Latin, but took time off for walks about the city and visits to museums and his uncle's art gallery. And, he confesses, "Now and then when I am writing, I instinctively make a little drawing, like the one I sent you lately: this morning, for instance, Elijah in the desert, with the stormy sky, and in the foreground a few thorn bushes. It is nothing special, but I see it all so vividly before me...." [101].

Vincent's room was, as usual, full of prints; he mentions a portrait of Anne of Brittany, a sheet from Bargue's *Cours de dessin* [115]. This book of drawing examples came to play an important role, for Vincent copied from it time after time once he had decided to become an artist. Not only at the beginning of his career but during the last months at Auvers as well, he went back to the plates in Bargue.

The Borinage

Because he wished to work with people, not with books, Vincent broke off his studies in Amsterdam in the summer of 1878 in order to attend a three-month course at the Training School for Evangelists in Brussels. While there he also assiduously visited the museums; on one happy occasion with Theo. He could no more refrain from looking at pictures than he could from drawing. "I should like to begin making rough sketches of some of the many things that I meet on my way...." [126]. But drawing, he says, would keep him from his "real work": preaching the Gospel. He assumes that the miners, as workers in darkness, have need of the Gospel. In England he had tried to become an evangelist among miners, but had been told he was too young. Now, although he had not finished the course, he wanted to be assigned to the Borinage, the coal-mining district near Mons.

After some difficulties with the evangelical committee, he set to work as a lay preacher among the miners, and began to draw them as well. Not much has survived, but a fellow-student at the training school in Brussels was one day visited by Vincent with a portfolio full of drawings of miners, "all very stiff and wooden," he himself said about them [126a]. Vincent saw the miners through the eyes of Charles Dickens, who in his novel *Hard Times* portrayed a Lancashire town in all its filth and social misery. Vincent recalled that the character of "Stephen Blackpool, a working man, is most striking and sympathetic" [131].

In the same letter he describes a call he paid on the Reverend Pietersen, a member of the evangelical committee, whose hobby was painting. He asked for one of Vincent's sketches of a typical miner. Vincent goes on immediately to say, "Often I draw far into the night, to keep some souvenir and to strengthen the thoughts raised involuntarily by the aspect of things here" [131]. He actually had no time for drawing, but could not leave it alone: it was his only pleasure. He asks Theo to thank Mr Tersteeg for a box of paints and a sketchbook sent as a

Jean François Millet, *The Diggers* (*Les bêcheurs*). Etching, 23 × 33 cm. Yale University Art Gallery, New Haven, Connecticut, bequest of Mrs Howard M. Morse

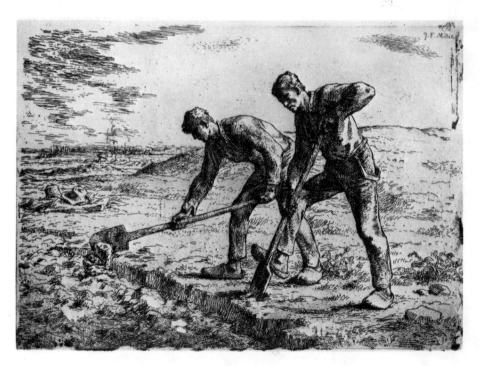

gift. He himself had recently bought a large sketch-book of old Dutch paper when he was in Brussels. Nevertheless, there is as yet no indication that Vincent contemplates an artistic career; at this time he is still an amateur in the true sense of the word.

This changed when his probation in the Borinage also ended in failure. Here, too, Vincent apparently could not keep himself from going to extremes: he gave away all his worldly goods, nursed the sick and the wounded, and behaved in a way which hardly became a man of the cloth. He was discharged and had nowhere to turn. The dark winter of 1879-80 followed, during which he undertook a journey, partly on foot, to Courrières in north-western France, hoping to introduce himself to the painter-poet Jules Breton, whom he deeply admired. Within sight of Breton's studio, however, his nerve failed him, and he turned round and trudged back to the Borinage. The trip to France was bitterly cold, he admitted much later. For bread, he traded drawings which he had taken along. Yet in the middle of this miserable time he felt his energy return, and he said to himself: "In spite of everything I shall rise again: I will take up my pencil, which I have forsaken in my great discouragement, and I will go on with my drawing. From that moment everything has seemed transformed for me; and now I have started and my pencil has become somewhat docile, becoming more so every day" [136].

Although he went briefly to Etten to see his family, he soon returned to the Borinage, destitute but independent, as he wrote at great length in his first letter to Theo in over eight months [133]. And now he really set to work to teach himself to draw. In August he wrote that he was busy making copies after Millet, which he continued to do (plate 3). He asked Theo to lend him more prints and reproductions. He was over the melancholy which had plagued him the past winter and which he had tried to fight off by reading a great deal: the Bible, Michelet's *Révolution française*, Shakespeare, Victor Hugo, Dickens, Harriet Beecher Stowe, Aeschylus, and much else besides.

Theo had sent him money at home, and Vincent accepted it against his will. He was sad because he had not yet succeeded in making a place for himself. Now that so many people had lost faith in him, he particularly valued Theo's moral support. The only things that enabled him to keep his head above water were his study and his work: "If I don't do anything, if I don't study, if I don't go on seeking any longer, I am lost" [133].

He was not lost, though things were very difficult. Because of his poverty, he was forced to share his room with a child. The space was so small he could not continue making his copies after the plates in Bargue. What he most wanted to

do was go to Paris or to Barbizon, but he was too poor for that and also felt that his work was not yet good enough. So he set out for Brussels, to renew his contacts with art and civilization, try to find some established artist willing to teach him, or perhaps attend the academy.

Brussels

Vincent realized very little of this ambitious plan in Brussels, but he vigorously continued his self-education, endlessly copying from various books of examples – a textbook on anatomy, an abridged edition of Lavater and Gall's *Physiognomy and Phrenology*, a book on perspective – and of course many reproductions and prints. His preferences were already clear: " I love landscape very much, but I love ten times more those studies from life, sometimes of startling realism, which have been drawn so masterfully by such as Gavarni, Henri Monnier, Daumier, De Lemud, Henri Pille, Th. Schuler, Ed. Morin, G. Doré (e.g. in his *London*), A. Lançon, De Groux, Félicien Rops, etc. etc." [140].

The work of these artist-illustrators had a deep and lasting influence on him. Vincent never sought to avoid their "startling realism" and that of the writers they illustrated. He himself hoped someday to become proficient enough to earn his living by illustrating. He also wanted to make a little collection of costumes, so that his future models would have something to pose in. This was still a dream in the autumn of 1880, but a few years later in The Hague it began to come true.

The greatest benefit of Vincent's six-month stay in Brussels was perhaps his acquaintance with Anthon van Rappard, a young Dutch aristocrat also there to study art. After an initial slight coolness between them, they hit it off splendidly and remained friends for five years. Van Rappard let Vincent work in his Brussels studio, a great convenience: "I have sketched two drawings at Rappard's, 'The Lamp Bearers' and 'The Bearers of the Burden'... " [143], memories of the Borinage (plate 4). His friend's imminent departure from Brussels in May 1881 helped Vincent decide that he, too, should leave.

Théophile Schuler, illustration in Erckmann-Chatrian, *Histoire d'un Paysan, 1789-1815*. Wood engraving, cut by S. Pannemaker ▶

Etten

To save money, Vincent returned about the middle of April to his parents' home in Etten. From this time on his development as draftsman is easy to follow. He worked a great deal out of doors and thoroughly enjoyed tramping about sketching with Van Rappard, who came for a short visit.

At the outset, Vincent's drawings were rather stiff. He often used a pen, attempting to achieve an exactness that seems almost painful (plate 5). His choice of subject matter was traditional. He wanted to become a painter of rural life (see plates 8, 9, 10, 11), like Jean François Millet or Jules Breton. Book illustrations continued to be an inspiration to him, as may be seen from the drawing *Worn Out* (plate 6). The title points to English illustrated magazines, and in composition the drawing resembles an illustration for Erckmann-Chatrian's novel *Histoire d'un paysan* by Théophile Schuler (page 14), whose work Vincent had always admired.

The neophyte artist Vincent van Gogh made quite rapid progress, much of it due to the help he received from the painter Anton Mauve. Since Mauve was a kinsman (his wife was a cousin of Vincent's mother), Vincent had easy access to him, visiting him in The Hague, where he also went to exhibitions and met other artists in their studios. Mauve presented him with a watercolor box, looked at his drawings, and recommended that he vary and extend his technique. Vincent was an eager pupil, drinking in Mauve's advice.

And then, back home again, new problems arose. His recently widowed cousin, Kee Vos-Stricker, daughter of his mother's elder sister, was staying in Etten, and Vincent fell in love with her. He dreamed: "If she with her lady's hand and I with my draftsman's fist are willing to work, the daily bread will not be wanting for us..." [157]. But it never got that far. Not only did his love remain unrequited, the whole family was scandalized by his behavior. He refused to accept Kee's "No, never never," writing to Theo, "I want her and her influence in order to reach a higher artistic level. Without her I am nothing, but with her there is a chance" [159]. Kee returned home to her parents in Amsterdam, and Theo lent Vincent money to go see her. She hid herself from him, however, though he stayed three days pleading his case unsuccessfully with his uncle and aunt.

Completely dejected, Vincent went back to Etten via The Hague, where he spent some time in Mauve's studio learning to watercolor. To encourage him, Mauve sent a painting kit and other material, and the gift was very welcome to Vincent: "For, Theo, with painting my real career begins. Don't you think I am right to consider it so?" [165].

But the atmosphere in Etten, and especially his relationship with his father, was not good. At Christmastime emotions erupted. Vincent stormed out of the house and headed for The Hague, leaving home for a long time.

The Hague

With Mauve's help, Vincent now installed himself for the first time in a studio of his own, in the Schenkweg on the outskirts of town. Mauve again became his teacher, encouraging him to paint and endeavoring to have him accepted as a member of the artists' society, Pulchri. The effort succeeded, so that Vincent was able to draw from a live model at the society's studio twice a week.

He also renewed his contacts with H. G. Tersteeg, manager of Goupil's gallery, and managed to sell him a small watercolour, for ten guilders. "Theo, it is almost miraculous!!!", he wrote; in March his Amsterdam art-dealer uncle, C. M. van Gogh, had commissioned him to make "12 small pen drawings... views of The Hague, apropos of some that were ready... At 2.50 guilders a piece, price fixed by me, with the promise that if they suit him, he will take 12 more at his own price, which will be higher than mine" [180]. Two of the drawings here reproduced (plates 14, 15) may have belonged to these series, for which Vincent eventually received thirty and twenty guilders, respectively (he completed only seven of the second group).

With this sale and promising commission, it seemed as if Vincent were finally on his way, but once again things went wrong. In January 1882, without telling Theo, he had begun to live with a pitiable, pregnant woman, Clasina (Sien) Hoornik – whom he had already used, along with her mother and her little daughter, as a model (plate 20). All at once he was head of a family, with mounting responsibilities, especially since neither his nor Sien's health was good, though her baby boy, born in July, was perfectly sound.

As word got around about their relationship, a difficult situation became even more so. Mauve and Tersteeg broke with Vincent, causing him to lose a large part of his circle of acquaintances in The Hague. Sien's own relatives were disagreeable, Vincent's horrified. Fortunately, Theo, once he had been informed, continued to lend financial support. Vincent probably personified some of his own feelings about the situation in the drawing *Sorrow* (plate 21), which he sent to Theo with the remark that he considered it the best figure he had yet done.

Besides various drawings of this subject, he also made a lithograph of it (plate 21). ⨯

Despite all the problems, Vincent made great progress in The Hague. A comparison of the figure studies he had done in Etten, in which the proportions are uncertain, with those of The Hague shows clearly that he not only had advanced technically but also had learned to get his models down on paper as entities (see plates 23, 24, 25). His sense of composition was much stronger, too. From Cassagne's *Guide de l'ABC du Dessin* he had learned the art of perspective. Previously he had thought that "getting depth and the right perspective into a drawing was witchcraft or pure chance" [184], but now he knew how to exploit perspective as an important means of expression. To prove his new mastery, he sketched the view from his studio window (plate 19). Later, to help himself even more, he designed and had made a portable perspective frame, "like a window.... Long and continuous practice with it enables one to draw quick as lightning – and, once the drawing is done firmly, to paint quick as lightning, too" [223]. References to such a frame occur time and again in his letters, sometimes with an accompanying sketch.

Vincent made paintings, watercolors, and drawings. For these latter he used various materials, different kinds of chalk, inks, graphite, charcoal (sometimes soaked in oil), and lead pencils, but he preferred a simple carpenter's pencil. He did not want "the beauty to come from my material, but from within myself" [195]. He was delighted to discover "black mountain crayon," which had fallen into disuse. With it he made a drawing of women and children being served at a public soup kitchen. "It's just as if there's a soul and life in that stuff, and as if it understood what you mean to express and co-operated. I should like to call it 'gypsy crayon,'" he wrote to Van Rappard [R 30].

In The Hague he continued his old custom of collecting prints, concentrating now primarily on wood engravings from such publications as the *Graphic* and the *Illustrated London News*. Vincent showed them to some of his acquaintances and wrote extensively about them to Van Rappard, with whom he also traded prints.[4] The painter B. J. Blommers spoke to him about giving a talk on his collection some evening at Pulchri, but the plan was vetoed by the board of the society.

Artistically, Vincent was making progress; domestically the difficulties con-

4 See the exhibition catalogue *English Influences on Vincent van Gogh*; this exhibition was organized by the Fine Art Department, University of Nottingham, and the Arts Council of Great Britain, in 1974-75. See also Jaap W. Brouwer, Jan Laurens Siesling, and Jacques Vis, *Anthon van Rappard, Companion and Correspondent of Vincent van Gogh: His Life and All His Works*, Amsterdam/Maarssen 1974.

cerning Sien increased. After nearly two years, he finally had to give up his attempt to build a home around "the woman," as he now referred to her, and the children. His conscience was heavy at the thought of abandoning them – he had grown especially fond of the little boy – but to avoid worse tensions and for the sake of his own work, he had to get away. He decided to go to Drente, a province in the east of the Netherlands at that time very popular with artists. His friend Van Rappard was working there, as was his other painter friend, George Breitner, with whom he had sometimes sketched in the streets of The Hague. The Drente countryside had a "very serious character," Van Rappard had written him, adding, "the figures often reminded me of studies of yours" [322]. In particular, he recommended the southeast corner of the province as "the most original." Living was also cheaper there than in the city. All this attracted Vincent, and so, making the best provisions he could for his little family, and hoping that Sien would not fall back into her old ways, he set out for Drente in late September 1883.

Drente

Vincent's expectations of the landscape were not disappointed. The great sweep of the heath, with its shades of purple, the marshy meadows, the moss-roofed cottages appealed to him as a painter. The people in the sod huts were poor and prematurely old, but he could hardly identify with their destiny. Since Van Rappard had already moved on to the island of Terschelling, Vincent was all alone, and he became quite despondent. "I take it so much to heart that I do not get on better with people in general," he wrote, and continued, "I am at a point where I need some credit, some confidence and warmth, and, look here, I find no confidence" [328].

Yet he persevered for a while, tramping in all directions to sketch and paint. In one of his illustrated letters (see plate 29), written from the remotest part of the region, he vividly described the beauty of the moors: "Level planes or strips of different color, getting narrower and narrower as they approach the horizon. Accentuated here and there by a peat shed or small farm, or a few meager birches, poplars, oaks... The figures which now and then appear on the plain are generally of an impressive character; sometimes they have an exquisite charm... what tranquillity, what expanse, what calmness in this landscape" [330].

Nuenen

Yet, after about two months, loneliness, despair, and the extreme cold drove him to seek shelter at his parents' home, now in Nuenen, a Brabant village in the neighborhood of Eindhoven. "A thing... I was very loath to do" [344], Vincent confessed in his first letter to Theo from there. He returned partly in order to lighten Theo's load in helping to support him, for he knew his brother was unhappy with his job. As a consequence, Vincent's own existence became more uncertain. His experience with Goupil led him to sympathize with Theo, toying with the idea of Theo's also becoming an artist, like himself.

The reception at home was kind and cordial, but basically nothing had changed regarding what Vincent called "the most extreme blindness and ignorance as to the insight into our mutual position" [345]. Vincent, who certainly did not make things easy for his family, met with a "certain hardness ... like iron, an icy coldness" in his father. He felt that he was scarcely accepted, and could not stand the feeling. When he was allowed to convert a little laundry room at the back of the house into a studio, he was able to get to work again and also to understand something of his father's attitude. Letters from Theo and Van Rappard encouraged him. Vincent went to The Hague to collect his possessions there and say goodbye to Sien. Living with her was no longer possible, although he suggested such a scheme to his father in order to attest his spiritual independence.

Soon Vincent was hard at work again, at first in the "mangle room," and then after a few months in a new and larger studio in the house of the sexton of the Catholic church. As subjects he chose primarily the local weavers trapped at their wooden looms in cramped spaces (plates 35, 36, 37). He drew a great deal with a pen, now using it also to make drawings after painted studies. He thought, rightly, that his drawings in this way were becoming more vigorous. A beautiful pen drawing of the vicarage garden in winter may be considered an independent work of art, of higher quality than he was able to achieve in his paintings. Vincent gave titles to such drawings. The *Winter Garden* of 1884 (plate 34) may well be compared with the drawing of the garden in Etten of 1881 (plate 5). Vincent now showed far greater control of his technique, and he was able to give a drawing coherent unity. His control of perspective is masterly. The favorite garden theme and the related one of a park, when Vincent was living in a city, recur constantly in his work. About the *Winter Garden* he said, "Indeed, this garden sets me dreaming...." [R 44]. Happy dreams, which he must also have had when he drew the bench in the garden of the hospital in Saint-Rémy (plate 83).

William Small, *The British Rough*, from the series "Heads of the People Drawn from Life." Wood engraving in the *Graphic*, June 26, 1875

Anthon van Rappard praised Vincent's drawings. In May 1884 he came for a fortnight's visit, and he and Vincent made little trips together. Van Rappard's enthusiasm for the natural beauty of Brabant was extremely stimulating. Vincent began to paint a great deal, inspired by the colors of the landscape, though he kept his palette dark. His painted studies ultimately reached a peak in 1885 in his first masterpiece: *The Potato Eaters*. With this he wished to make his debut in the art world. After four years of hard work he felt strong enough to take that risk. Therefore he felt all the more crushed by the criticism of Van Rappard, who did not like the painting and accused him of doing violence to nature. If that is true, replied Vincent in so many words, then the violence was intended to enhance the expressive force. He was still striving to express the essence of his subjects rather than to evoke a sensitive mood with color and tone. This goal is clearly evident in the series "Koppen uit het volk" (plates 39, 40), which was inspired by the English series "Heads of the People" published in the *Graphic* (see page 19).

Vincent made a number of preparatory sketches for *The Potato Eaters*, including a lithograph (plates 42, 43), and in the varying compositional versions his drawing style underwent a decisive change. The result of a new vision of rendering the plasticity of forms, this change can be traced in several of his studies of hands (see page 21). Vincent had discovered a truth: "In drawing, for instance – that question of drawing the figure starting with the circle – that is to say, using the elliptical planes as a foundation. A thing which the ancient Greeks already knew, and which will remain valid till the end of the world" [402]. He mined this wisdom from a book, sent to him by Theo, *Causeries sur les artistes de mon temps* by J. F. Gigoux (1885). Through this book, he became more conscious of his use of color and manner of drawing. "At present I am busy putting into practice, on the drawing of a hand or an arm, what Delacroix said about drawing: "Ne pas prendre par la ligne mais par le milieu." That gives opportunity enough to start from ellipses. And what I try to acquire is not to draw *a hand* but the *gesture*, not a mathematically correct head, but the general *expression*. For instance, when a digger looks up and sniffs the wind or speaks. In short, *life*" [408].

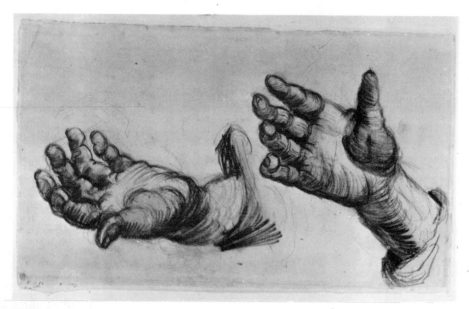

Vincent van Gogh, *Study of Hands*. Nuenen, April 1885. Black chalk, 21×34.5 cm (F 1153 recto). Vincent van Gogh Museum, Amsterdam

Vincent van Gogh, *Study of a Right and a Left Hand*. Nuenen, January-February 1885. Pencil, 21×34.5 cm (F 1154), Vincent van Gogh Museum, Amsterdam

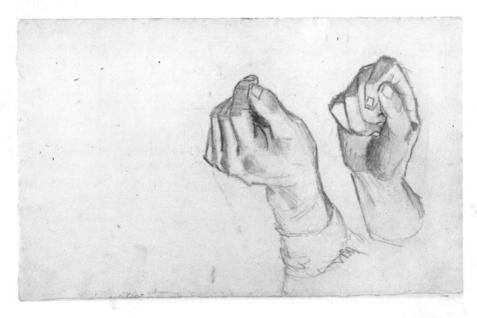

Antwerp

It was this fundamental idea that ran counter to the academic manner as pursued at the Antwerp academy and other such institutions. Yet Vincent, during the summer of 1885, determined to go to Antwerp. His father had died very suddenly at the end of March, his mother would soon be leaving Nuenen, and his reputation in the village was under a cloud, through no fault of his own, he maintained. Late in November, therefore, leaving nearly all his sketches and other work behind (in cases that were dispersed or destroyed), he set out for Antwerp in order to be in a city once again and to study drawing from models at the academy. The "academic gentlemen," he predicted, would accuse him of heresy. This did not prevent his from going his own way, or even from influencing his fellow-students. Indeed, Vincent always attracted "pupils." That side of him, at least, had not changed since his time in England as assistant teacher.

In the class in "antique" drawing – drawing from plaster-casts of classical statuary – at the Antwerp academy, the "lessons" Vincent himself contributed brought him into conflict with the instructor, Eugène Siberdt. Academicism, with its total emphasis on finding the correct contour, became so repugnant that Vincent wrote to Theo, "And now you ought to see how flat, how lifeless and how insipid the results of that system are; oh, I can tell you, I am very glad just to be able to see it close up" [452].

To Vincent, neither color nor line was all-important. Not line, but "le modèle est la probité de l'art," he had already said at Nuenen [408], quoting the critic Paul Mantz, who himself had altered a pronouncement by the academic painter Ingres that line was most important. Later, in Paris, Vincent arrived at the theory that true drawing is modeling with color – a conviction he was also able to put into practice.

Antwerp with its museums and churches full of the work of Rubens and other Southern Netherlanders, its busy harbor, its pubs and cafés, stimulated Vincent anew. The big city was so different from the slow farming life of Brabant. As he rushed around making sketches (plates 50, 51, 52), the "unfathomable confusion" reminded him of a saying of the Goncourts: "Japonaiserie forever" [437]. It was the writings of the Goncourt brothers, whom he vastly admired, that led Vincent to Japanese prints (see page 26). To him the Japaneseness lay first of all in the subject, that is, in the fantasy and interesting contrasts. In Paris he deepened his knowledge of Japanese prints by collecting and copying them. Even earlier, in Antwerp, he had tried to capture something "Japanese" in

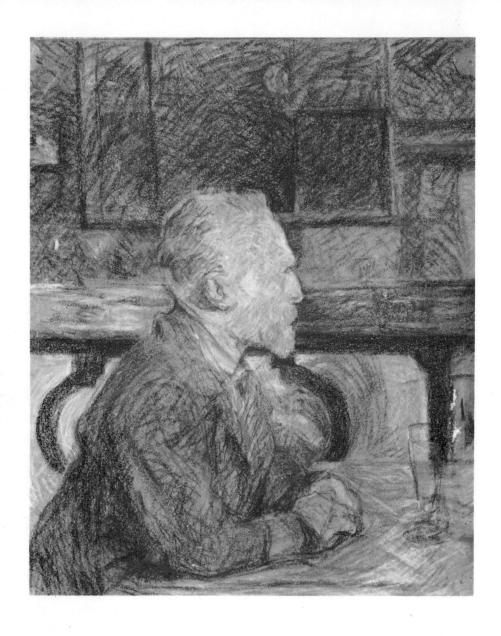

Henri de Toulouse-Lautrec, *Vincent in the Café*, Paris, 1887. Pastel, 57 × 46.5 cm. Vincent van Gogh Museum, Amsterdam

sketches of a café concert (plate 53). Here the capricious movement is set down in a new medium – pastel crayon – which Vincent had just started to use, no doubt again inspired by the Goncourts and their book about eighteenth-century artists such as the pastellist Quentin-Latour. Many nineteenth-century artists followed the same example, Degas and Odilon Redon reaching peaks of artistry with their pastels. In Paris, Toulouse-Lautrec made a pastel portrait of Vincent (see page 24).

Paris

For a long time Vincent's real goal had been Paris, where he could live with Theo, study drawing after models in Cormon's studio, and learn about earlier art in the museums. He wanted to continue his education in the same way the painter Breitner had done: Breitner worked in Cormon's studio in 1884 and met Theo van Gogh, who wrote to Vincent about it. Outside the official academies there were virtually no possibilities for good instruction, so Vincent, despite his wilful ideas, was obliged to follow the traditional way.

His admiration of the old masters was so great that at first he was little attracted by the work of the Impressionists. But this changed rapidly in 1887, after he had met a number of painters, among them not only Impressionists and Pointillists but also others who worked with a much greater surface style, which Vincent called Japanese. All represented new developments in art, and Vincent tried to join in. He experimented in his drawings with the Impressionist technique of short strokes or dots of color. In a series of views of the suburbs of Paris (plates 56, 58, 59, 60), he developed a technique about midway between watercolor and line drawing. The drawings have color and a totally individual rhythm. This rhythm, evolved from the Impressionist painting technique, became and remained a basic characteristic of Vincent's work.

Another influence was Japanese prints, which Vincent avidly collected and studied, as he had done earlier with English prints. The Japanese influence was not limited to prints, however. Vincent must have made a whole study of the

5 In the August 1887 issue of the *Gazette des Beaux Arts*, Gonse reviewed William Anderson's *The Pictorial Arts of Japan* and the catalogue Anderson made for the collection of Japanese and Chinese paintings in the British Museum. In 1885 Gonse himself had published a book about Japanese art.

Hiroshige, *Bridge in the Rain*. Colored woodcut. Vincent van Gogh Museum, Amsterdam ▶

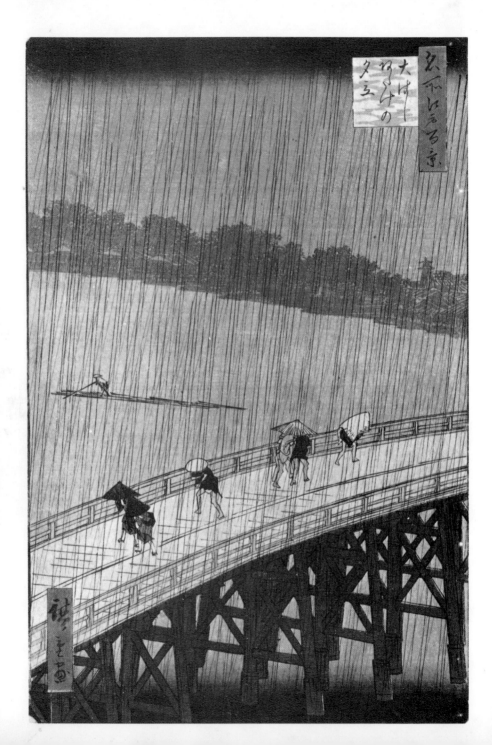

background and theories of oriental art. Books and articles had been published on the subject, including those by the French expert Louis Gonse.[5] Vincent's Japanism was no longer restricted to subject and composition, but was expressed primarily in a rapid working method. Later, in the South of France, he became, so to speak, a Japanese. His need for "japonaiseries" was over, for, he wrote to his youngest sister, Wilhelmina, "I am always telling myself that here I am in Japan" [W 7]. This is typical of the basic and rapid way in which Vincent absorbed artistic influences – by assimilating them completely.

Vincent called Paris "a hotbed of ideas," where "people try to get everything out of life that can by the remotest chance be got out of it. Other cities become small in comparison with it, and it seems as big as the sea. There one always leaves behind a considerable part of one's life" [W 4]. Vincent "got out" what there was for him. Artistically he was successful, commercially not yet – although one of the reasons for his coming to Paris in the first place was to earn money.

The South of France

In February 1888 Vincent once more exchanged the city for the country, traveling through the snowy countryside to Arles in Provence. He enjoyed the country, especially when spring came. He was delighted with the orchards, which he drew and painted (plate 62). The strong mistral winds often made it impossible to paint; Vincent then made small pen drawings. Another reason for him to draw rather than paint was his chronic lack of money. In the spring and summer he created a series of elaborate pen drawings in the surroundings of Arles which in composition and execution are just as important as his paintings (plates 68, 69, 70). These sheets are unusually rich in textures, which he introduced with various pens – thick reed pens and goose feathers – on top of a preliminary chalk drawing. The softness of the vegetation and the hardness of the rocky ground, the lights and the darks: Vincent was able to evoke so much that color is not in the least missed. He was himself extraordinarily proud of these large pen drawings, not wishing to sell them for less than one hundred francs apiece.

The drawings that Vincent made during his trip to Saintes-Maries-de-la-Mer in June (plates 64, 65, 66) also display the virtuosity of his drawing technique. He wrote to Theo: "The Japanese draw quickly, very quickly, like a lightning flash, because their nerves are finer, their feeling simpler. I am convinced that I shall

set my individuality free simply by staying on here. I have been here only a few months, but tell me this – could I, in Paris, have done the drawing of the boats *in one hour?* Even without the perspective frame, I do it now without measuring, just by letting my pen go" [500]. The implication is clear: Vincent drew in the spirit of a simple, enlightened Japanese artist. Yet the use of the reed pen in these drawings is more suggestive of Rembrandt, whose drawings Vincent was well acquainted with. What is remarkable is that now, as in The Hague with the black mountain crayon, he chose once again an old-fashioned, seldom-used material. And he was obviously still relying on his well-loved, well-tried perspective frame.

In his *Japan in the South of France,* Vincent dreamed of establishing a communal studio of mutually congenial artists. As the fall of 1888 drew on, he furnished a room for Paul Gauguin in the little yellow house he had rented in Arles in May (colorplate III). Full of excitement and worry, Vincent waited for his friend and acknowledged master to arrive. What would Gauguin say of his work? When he finally came, in October, nothing went quite according to Vincent's plans. Almost immediately it appeared that Gauguin, seconded by Emile Bernard, with whom he was in correspondence, held decided views about art. The two of them championed abstracting, instead of copying nature as the Impressionists did. They recommended working with the mind, the imagination. Vincent tried to do so, but succeeded to only a slight degree. Clutching at proven methods, he copied the work of both Gauguin and Bernard (plate 81). The emphasis was on unstructured areas enclosed within lines. Modeling was almost ignored, and there was no question of "prendre par le milieu." For Vincent this experiment was short-lived, although in his later work he did make greater use of long flowing lines.

Working with Gauguin created such tensions that Vincent in an access of frenzy threatened his friend with a knife. But instead of stabbing Gauguin, he wounded himself. Vincent cut off a piece of his ear and took it as a gift to a woman in a local brothel. These events around Christmas of 1888 forced Gauguin into flight and poor Vincent into a hospital. Thus ended the period of great creativity in Arles. Vincent's mental illness had become acute, and a solution had to be found. The people of Arles were hostile and petitioned the mayor for his removal. Finally it was decided, by the doctor, the Protestant clergyman in Arles, and Vincent himself, that he should go to an asylum near-by at Saint-Rémy. Before his departure, he wrote to Theo: "If I were without your friendship, they would remorselessly drive me to suicide, and however cowardly I am, I should end by doing it" [588].

Vincent entered the hospital of Saint-Paul at the beginning of May 1889, "as much for my own peace of mind as for other people's" [585]. Imprisoned between the walls of the institution, he found artistic inspiration and themes in the ancient monastery building, the lush garden with oleanders and pine trees, and the court-yard with its picturesque fountain (colorplate I; plates 82, 83, 84).

During the year he spent at Saint-Rémy, Vincent's drawing style evolved still further. Instead of clear contrasts by means of various sorts of strokes, little dashes, scratches, and points, his technique became more unified. Everything was set down in large swirling movements in which lines and textures became inde-pendent. This came about partly because of the kinds of trees and plants he drew, but the emphasis on line and stylization can also be seen as Vincent's answer to Gauguin and Bernard's new decorative style, in which creating from memory played a principal role. Vincent sent for the old studies he had done during his Brabant period, so that he could make his own "souvenirs of the north." Feeling completely isolated, he turned to copying the work of other artists as well – Rembrandt, Delacroix, Millet. This choice of artists points back to his old ideas and preferences. He returned, too, to his own first important work, *The Potato Eaters*. Indeed, it is precisely the sketch of the peasant family eating (plate 92) that attests most clearly to Vincent's strong development as an artist just as his health was deteriorating. He was haunted by fear of new attacks.

It was of vital importance to Vincent to leave the asylum, and he planned, with the help of Theo, who in the meantime had married, to go north. In May 1890 he managed to do so, leaving the South of France and staying several days in Paris with Theo, his wife Jo and their baby boy, Vincent's namesake. Afterwards he traveled to Auvers-sur-Oise, a peaceful village an hour's train journey north of Paris, where such artists as Daubigny, Pissarro, and Cézanne had worked. Dr Gachet, a friend of these artists, lived there and had agreed to keep an eye on Vin-cent's health.

The End in Auvers

Vincent rather liked Auvers. He worked industriously, but was not very opti-mistic. He projected his anxiety upon the little nephew who bore his name but, he dearly hoped, would have a "soul less unquiet" than his [648]. For the time being his work kept him going. He asked Theo to send him his old book of

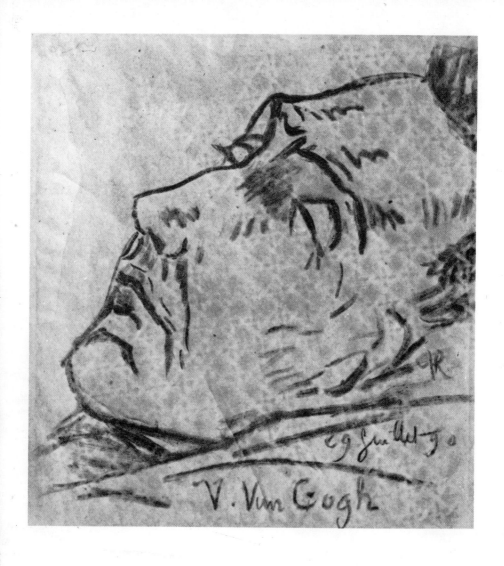

Paul Gachet, *Vincent on His Deathbed*, July 29, 1890. Drawing. Cabinet des Dessins, Louvre, Paris

drawing examples, Bargue's *Exercices au fusain*. "I need it urgently, I will copy them so as to keep the copies for good" [636]. He continued to work, yet an almost resigned tone crept into the letters, and Vincent dared trust in a better future no longer. Although he ordered new paint and wrote at length about what he was doing, including sketches (plate 97), he was driven at last to attempt suicide. After lingering a few days, he died, with Theo beside him, on July 29, 1890. Dr Gachet sketched him on his deathbed (see page 30).

Vincent fought his artistic battle, as he himself thought of it, to the very end. It is tragic that at the moment of his death he had come to be known and appreciated by a small circle as an artist whose work was still developing. In his last drawings we see a great diversity of techniques and materials: chalk, pen, and brush. On one sheet he sketched a perspective frame, apparently to explain it to someone (plate 98). He continued to use the aids that had helped him from the beginning. By his own lights, he had accomplished but little so far, certainly in comparison with other artists. We know now that he created an exceptional and influential body of work, particularly as a painter of brilliant colors.

His path is most easily followed in his drawings. After a difficult beginning, he was able to achieve true heights in his landscapes and peasant figures of North Brabant. His drawing style at that time was still traditional. Through his contacts in Paris with avant-garde artists and the art of the Far East, Vincent developed his own free and spontaneous style, experimenting with color in his drawings and paintings alike. In the South of France this led to a masterly series of landscape drawings. Then came his first mental collapse. The drawings he made at the asylum at Saint-Rémy and later in Auvers show a change of style. As an artist, Vincent continued to develop. As a human being, he had to give up, and shot himself.

Vincent's mental illness left traces on his work, yet too often this influence has been misinterpreted or oversimplified. The late drawings of plants, made with a reed pen, show great self-control (plates 99, 100). Well-observed and beautifully set down, they make a fitting farewell to the draftsman Vincent van Gogh.

Colorplates

I

The Hall at the Hospital of Saint-Paul

May-June 1889, Saint-Rémy
Black chalk, gouache, 61.5 × 47 cm (F 1530)
Vincent van Gogh Museum, Amsterdam

II

La Barrière with Horse-drawn Tram

Summer 1887, Paris
Watercolor, pen and pencil, 24 × 31.5 cm (F 1401)
Vincent van Gogh Museum, Amsterdam

III

Vincent's House at Arles

September-October 1888, Arles
Chalk, pen, brown ink and watercolor, 25.5 × 31.5 cm (F 1413)
Vincent van Gogh Museum, Amsterdam

IV

Old Vineyard with Peasant Woman

Late May 1890, Auvers
Pencil, brush, washed with blue, red, and white gouache, 43.5 × 54 cm (F 1624)
Vincent van Gogh Museum, Amsterdam

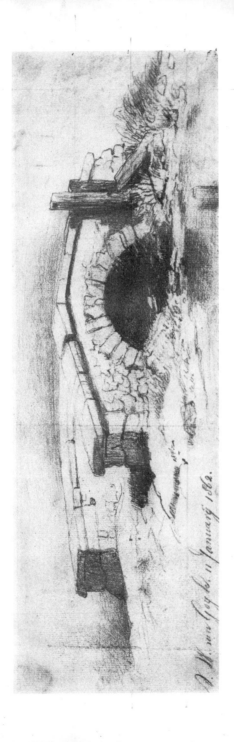

I

The Bridge (after a drawing example by V. Adam)

January 11, 1862, Zundert
Pencil, 12 × 36.5 cm
Kröller-Müller Museum, Otterlo

2
The "Lange Vijverberg"

Spring 1873, The Hague
Pen and brown ink, pencil, 22 × 17 cm (F 837)
Kröller-Müller Museum, Otterlo

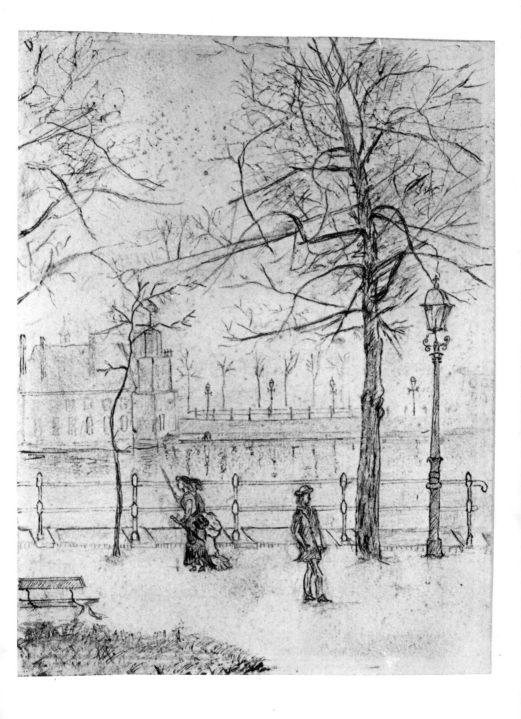

3
The Diggers (after Millet)

October 1880, Brussels
Pencil, stumped, and charcoal, 37 × 62 cm (F 829)
Kröller-Müller Museum, Otterlo

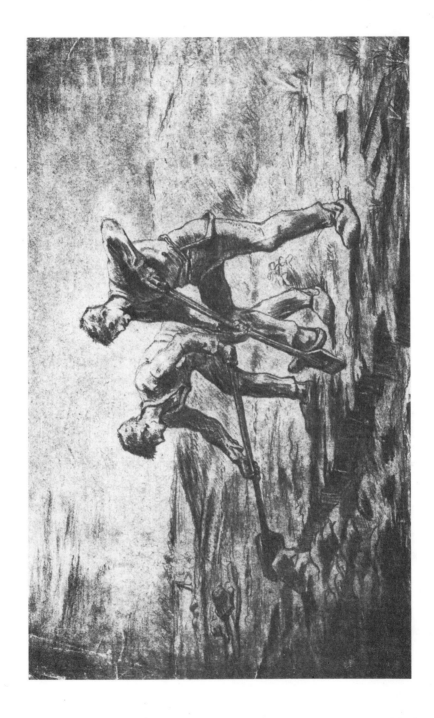

4

Miners' Wives Carrying Sacks (The Bearers of the Burden)

April 1881, Brussels
Pen, pencil, brush, 43 × 60 cm (F 832)
Kröller-Müller Museum, Otterlo

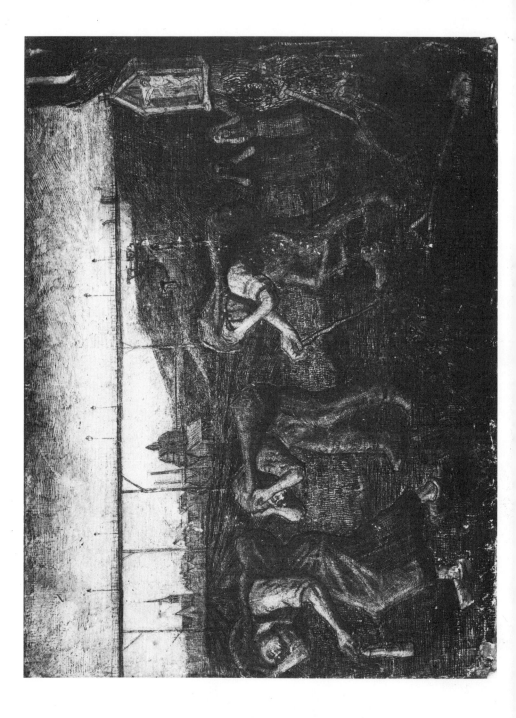

5
Corner of a Garden with an Arbor

June 1881, Etten
Pencil, black chalk, pen and watercolor, 44.5 × 56.5 cm (F 902)
Kröller-Müller Museum, Otterlo

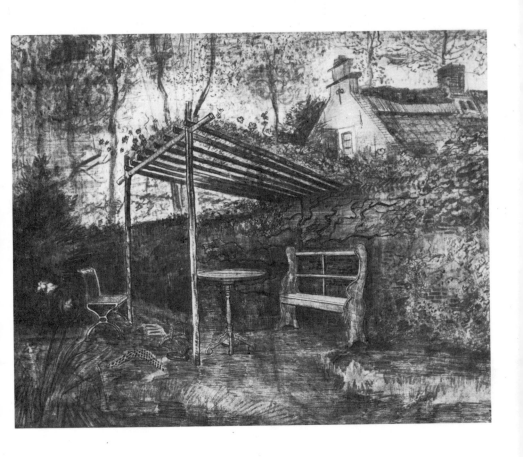

6

Old Farmer by the Fire (Worn Out)

Fall 1881, Etten
Sketch in letter 150 (September?)

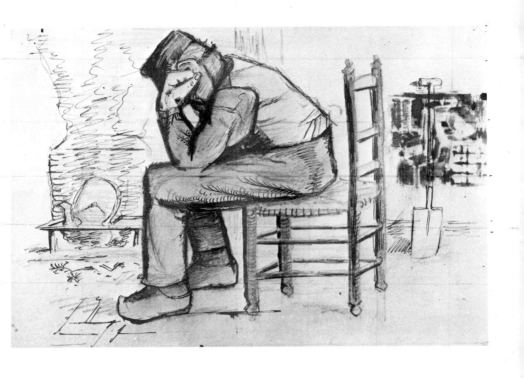

7
Windmills on the Weeskinderendijk at Dordrecht

Fall 1881
Watercolor, pencil, black and green chalk, heightened with white, 26×60 cm (F 850)
Kröller-Müller Museum, Otterlo

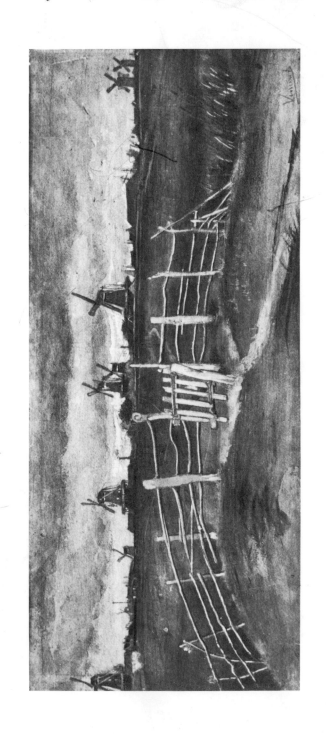

8
Young Peasant Digging

September 1881, Etten
Charcoal, washed, and watercolor, heightened with white, 52 × 31.5 cm (F 855)
Kröller-Müller Museum, Otterlo

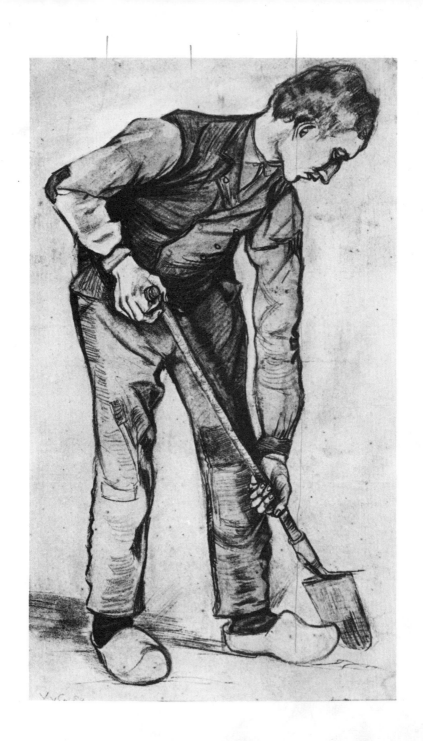

9

Young Girl Gardening

December 1881, Etten
Black chalk and watercolor, 58×46 cm (F 884)
Museum van Baaren Foundation, Utrecht

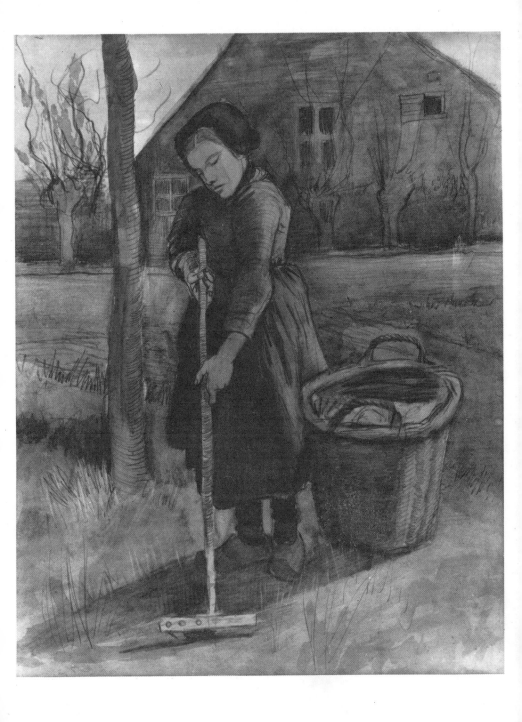

Road into Leuren

October 1881, Etten
Sketch in letter 152

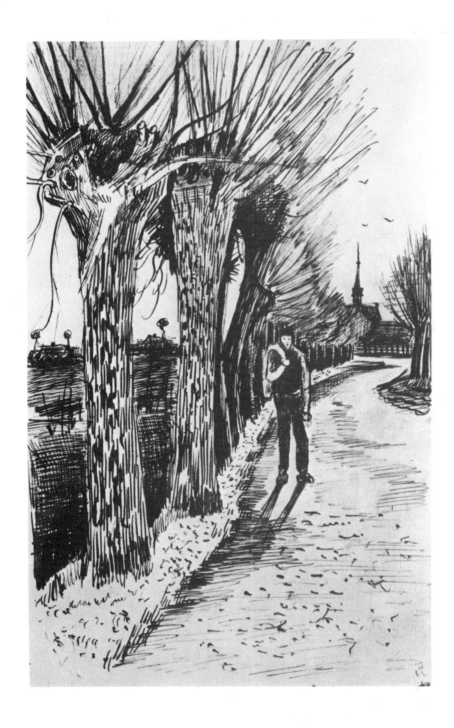

II

Donkey Cart

Fall 1881, Etten
Charcoal, black chalk, washed and heightened with white, 42 × 59.5 cm (SD 1677)
Vincent van Gogh Museum, Amsterdam

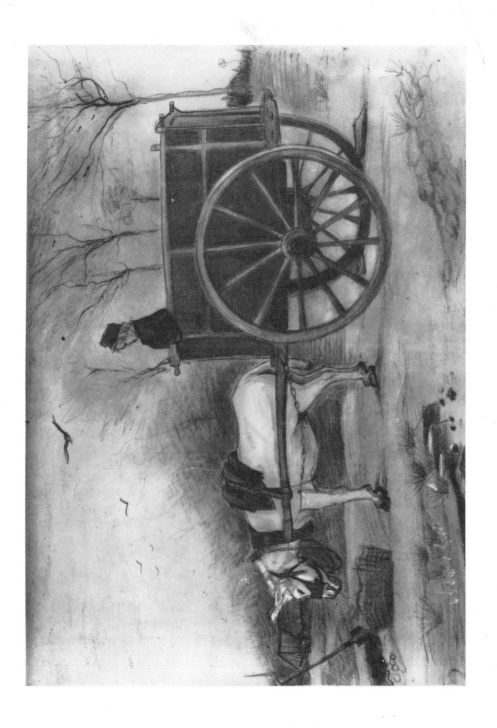

12

Young Fisherwoman from Scheveningen

December 1881, The Hague
Watercolor, 23.5 × 9.5 cm (F 871)
Vincent van Gogh Museum, Amsterdam

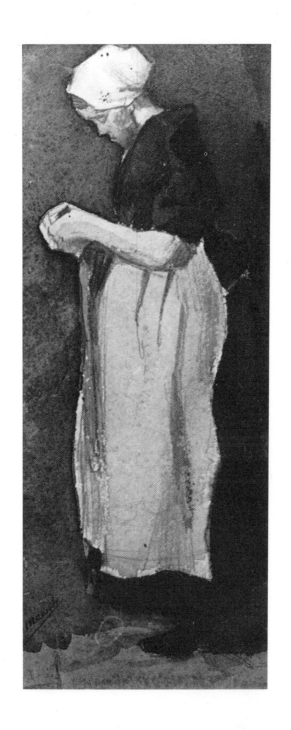

13

Road in Loosduinen

Early 1882, The Hague
Black chalk and pen, heightened with white, 26 × 35.5 cm (F 1089)
Vincent van Gogh Museum, Amsterdam

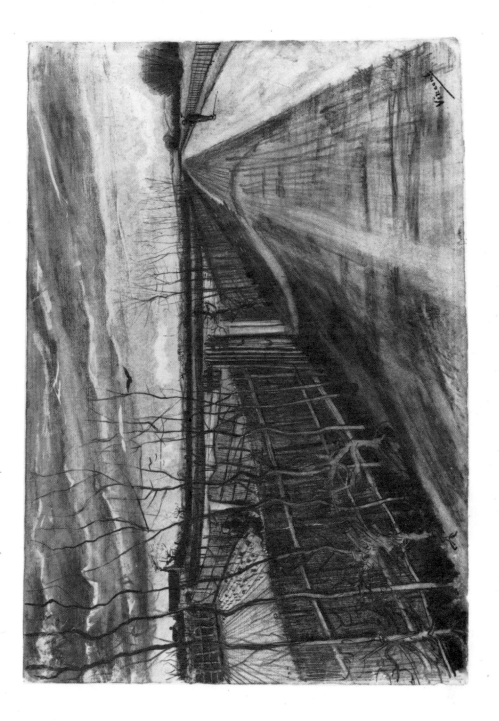

14

Corner of Herengracht and Prinsessegracht, The Hague

March 1882
Pencil, washed with China ink, heightened with white, 24 × 33.5 cm (SD 1679)
Vincent van Gogh Museum, Amsterdam

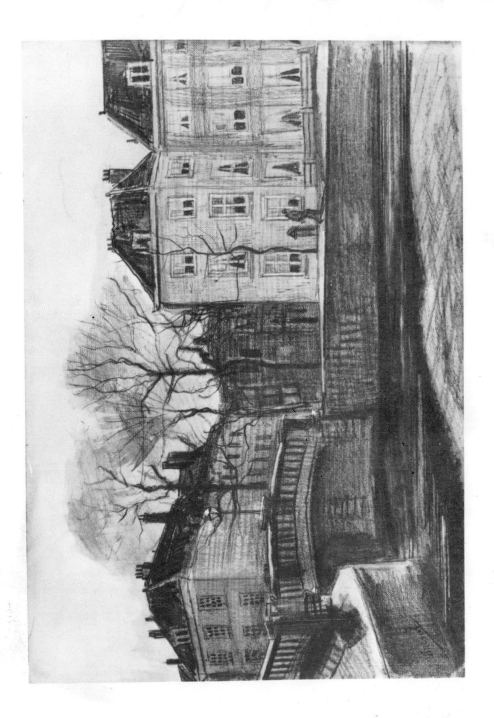

Paddemoes, the Jewish Quarter of The Hague

February-March 1882
Pen and ink, pencil, 25 × 31 cm (F 918)
Kröller-Müller Museum, Otterlo

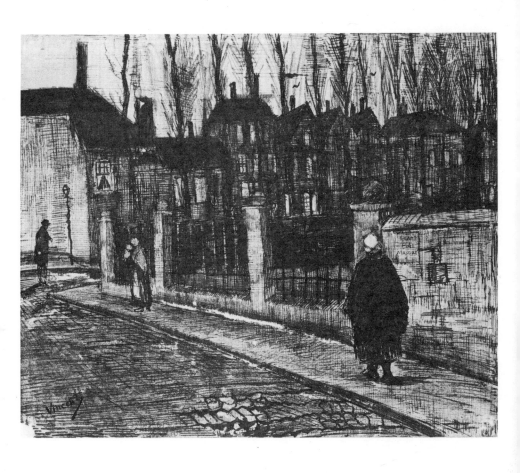

16

Boats on the Beach at Scheveningen;
Lumberyard at Rijswijk

July 1882, The Hague
Sketches in letter 220

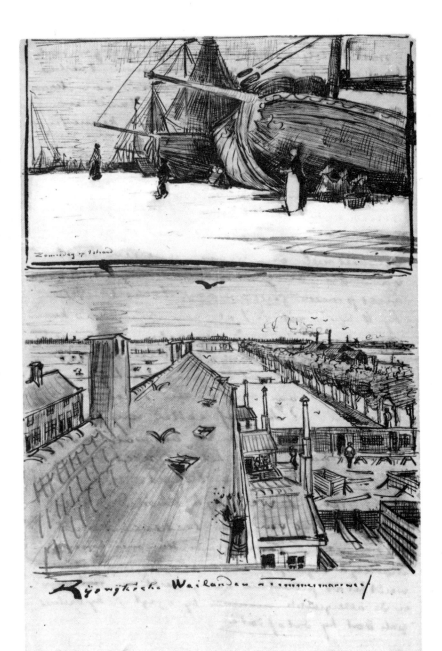

Zomerdag op 't strand

Rijswijkscha Weilanden en timmermanswerf

219

17

Woman Walking with a Stick

March 1882, The Hague
Pencil, pen and brown ink, washed, 57×32 cm (F 913)
Vincent van Gogh Museum, Amsterdam

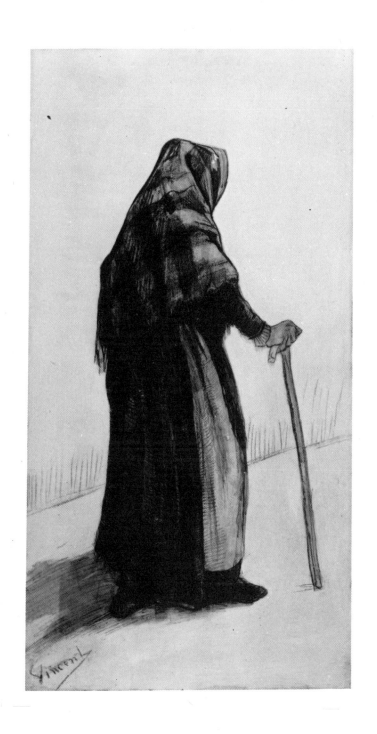

18
Study of a Tree

April 1882, The Hague
Black and white chalk, black ink, pencil, watercolor, lightly washed, 51×71 cm (F 933 recto)
Kröller-Müller Museum, Otterlo

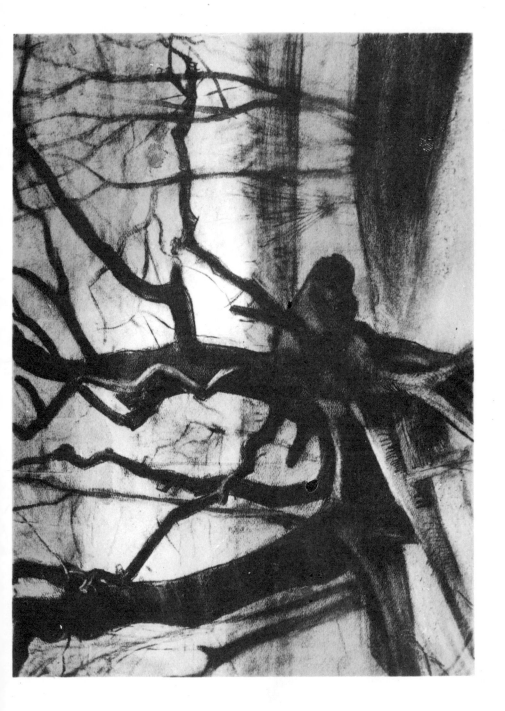

19
Carpenter's Workshop, Seen from the Artist's Studio on the Schenkweg

May 1882, The Hague
Pencil, ink, pen and brush, heightened with white, 28.5 × 47 cm (F 939)
Kröller-Müller Museum, Otterlo

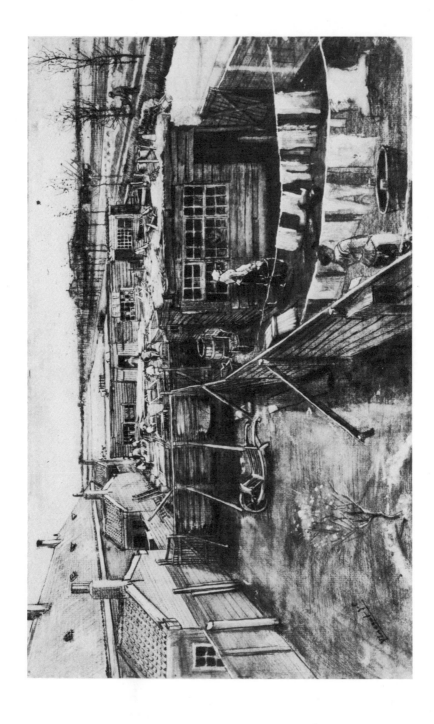

20

Sien with a Cigar, Sitting on the Floor by the Stove

April 1882, The Hague
Pencil, black chalk, pen and brush, sepia, washed and heightened with white, 45.5 × 56 cm (F 898)
Kröller-Müller Museum, Otterlo

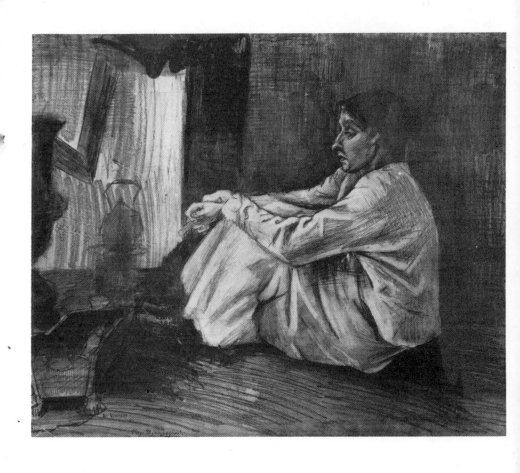

21

Sorrow

November 1882, The Hague
Lithograph, 38 × 29 cm (F 1655)
Vincent van Gogh Museum, Amsterdam

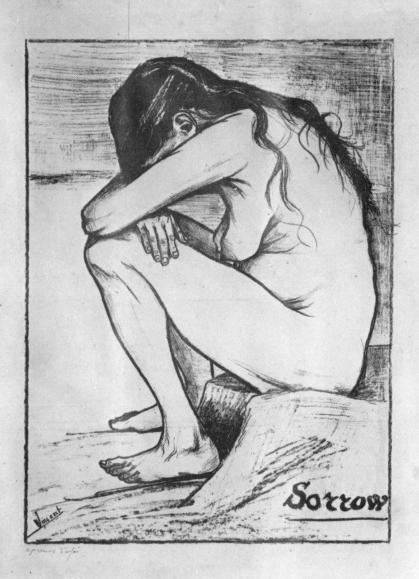

Sorrow

22

The State Lottery Office

October 1882, The Hague
Watercolor, 38 × 57 cm (F 970)
Vincent van Gogh Museum, Amsterdam

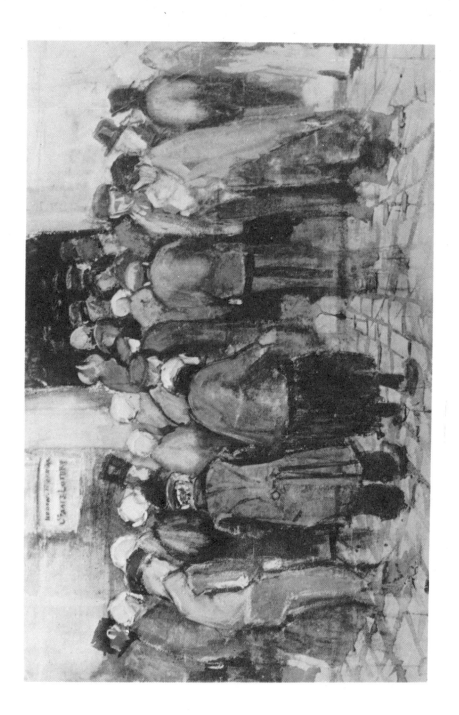

23

An Old Man from the Almshouse

September-December 1882, The Hague
Pencil, 50 × 30.5 cm (F 962)
Vincent van Gogh Museum, Amsterdam

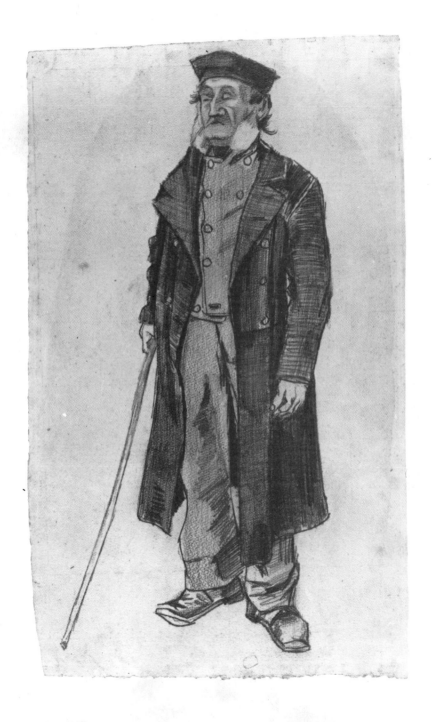

24
An Old Man from the Almshouse Drinking Coffee

November 1882, The Hague
Black lithographic chalk, 49.5 × 28.5 cm (SD 1682)
Vincent van Gogh Museum, Amsterdam

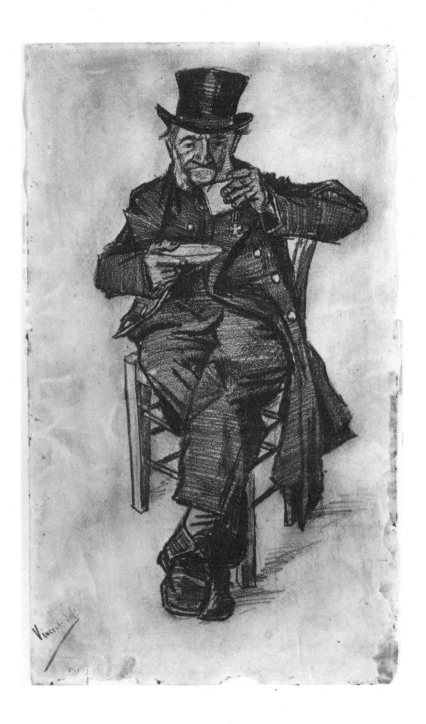

25

Fisherman with Pipe

July 1883, The Hague
Pen, pencil, black chalk, washed, heightened with white, 46 × 26 cm (F 1010)
Kröller-Müller Museum, Otterlo

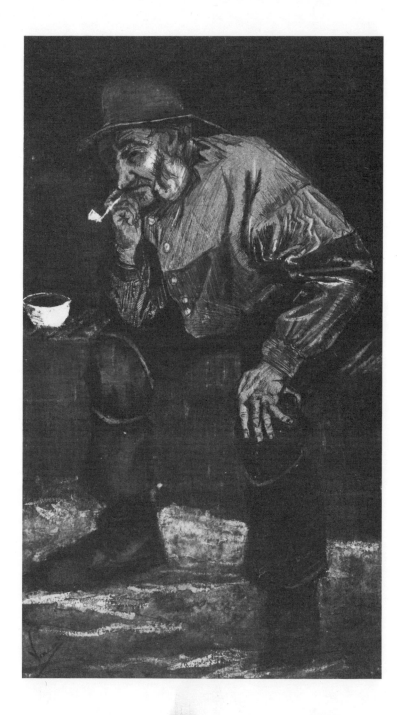

26

Sien's Daughter Seated

January 1883, The Hague
Pencil, black lithographic chalk, 50.5 × 31 cm (F 100
Vincent van Gogh Museum, Amsterdam

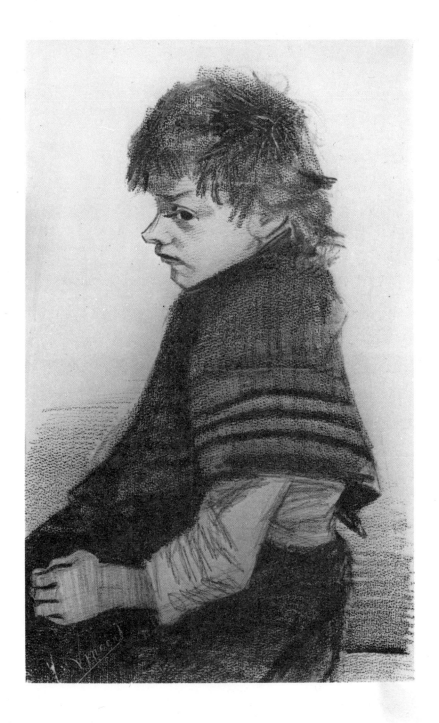

The Public Soup Kitchen

March 1883, The Hague
Pen, 10 × 10 cm (F 1020)
Vincent van Gogh Museum, Amsterdam

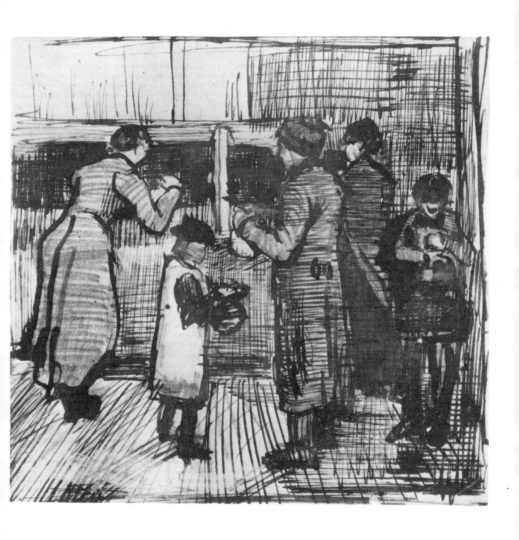

28

The Drawbridge at Nieuw-Amsterdam

November 1883, Drente
Watercolor, 38.5 × 81 cm (F 1098)
Museum voor Stad en Lande, Groningen

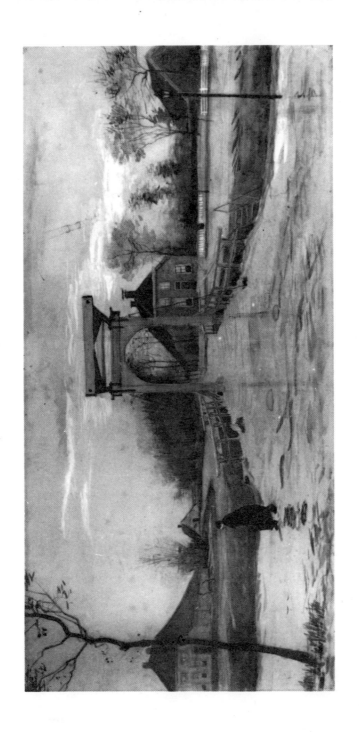

29

October 1883, Drente
Sketches in letter 330

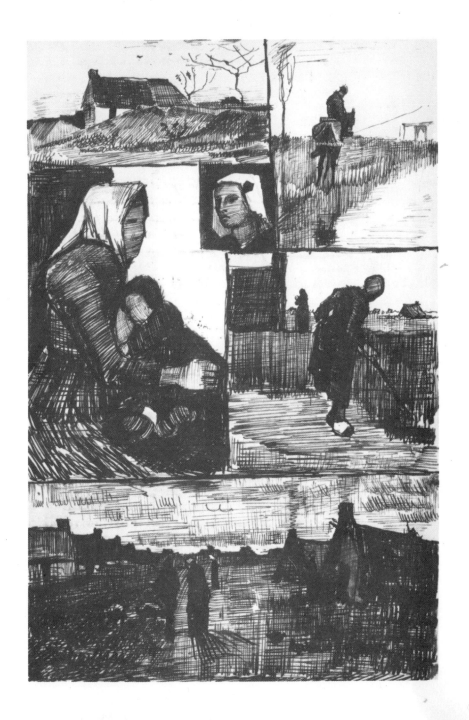

30
Cottages on the Heath

October 1883, Drente
Black chalk, heightened with white, 46 × 60.5 cm (F 1248)
Kröller-Müller Museum, Otterlo

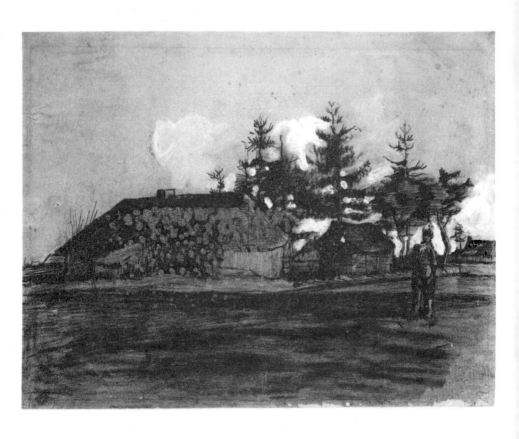

31
Winter Landscape

December 1883, Nuenen
Pen and pencil, 20.5 × 28.5 cm (F 1232)
Kröller-Müller Museum, Otterlo

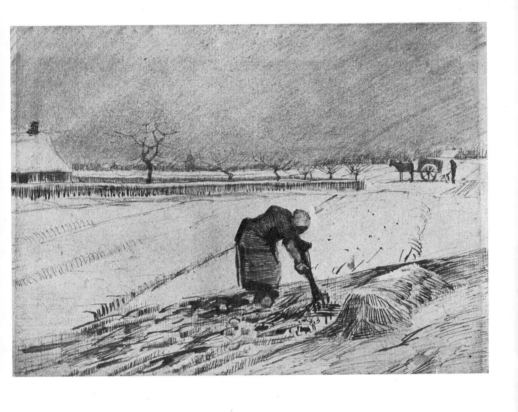

32

The Church at Tongelre in Winter

December 1883, Nuenen
Pencil, pen and ink, 20.5 × 28.5 cm (F 1238)
Vincent van Gogh Museum, Amsterdam

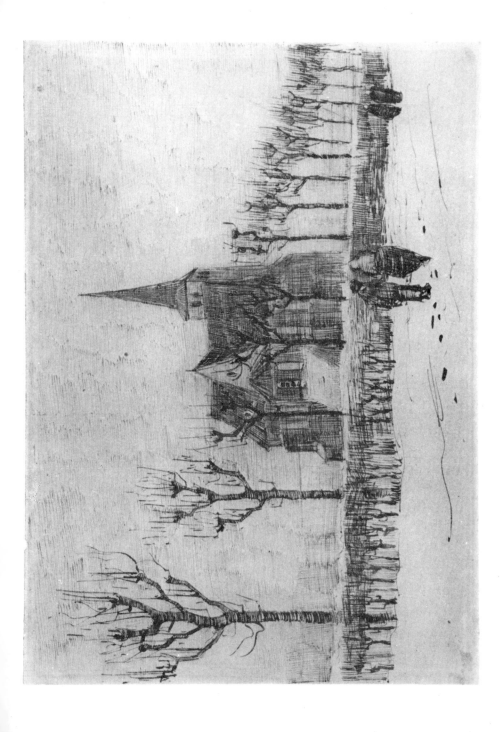

33
The Wood Sale

January 1884, Nuenen
Watercolor, 33.5 × 44.5 cm (F 1113)
Vincent van Gogh Museum, Amsterdam

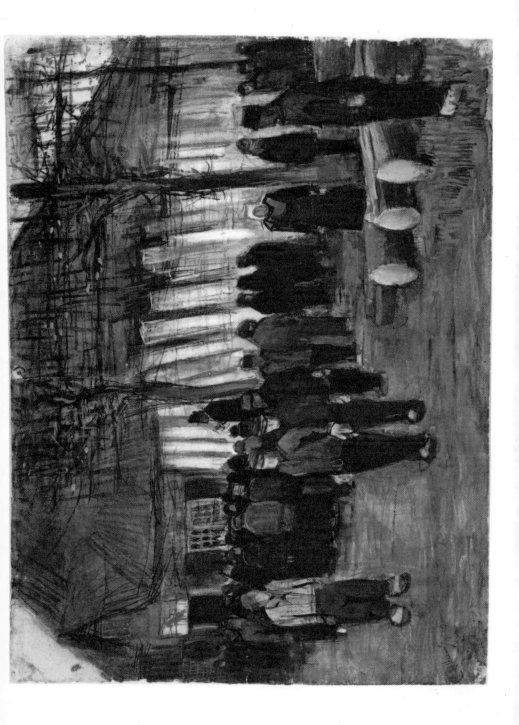

34

The Vicarage Garden at Nuenen in Winter

March 1884, Nuenen
Pencil and pen, 39 × 53 cm (F 1128)
Vincent van Gogh Museum, Amsterdam

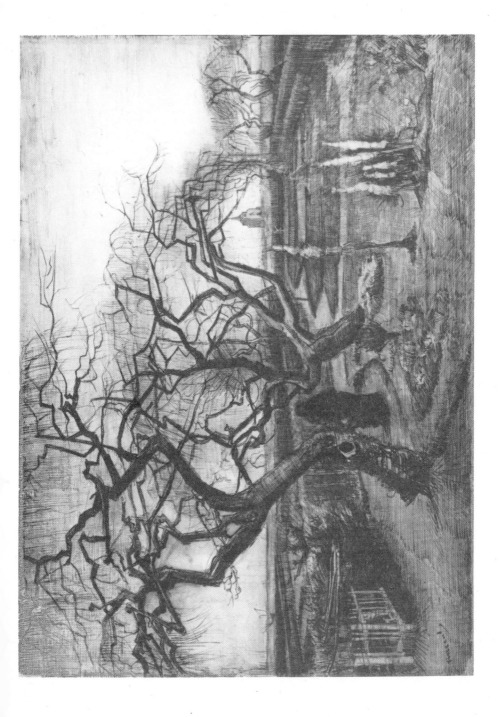

35
A Farmhouse Interior; A Gardener; A Weaver

January 1884, Nuenen
Sketches in letter 351a

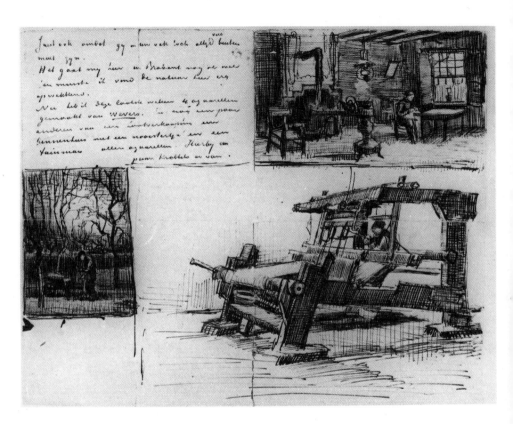

36
Man Reeling Yarn

May-June 1884, Nuenen
Pencil, black chalk, pen and ink, 22.5 × 23 cm (F 1138)
Kröller-Müller Museum, Otterlo

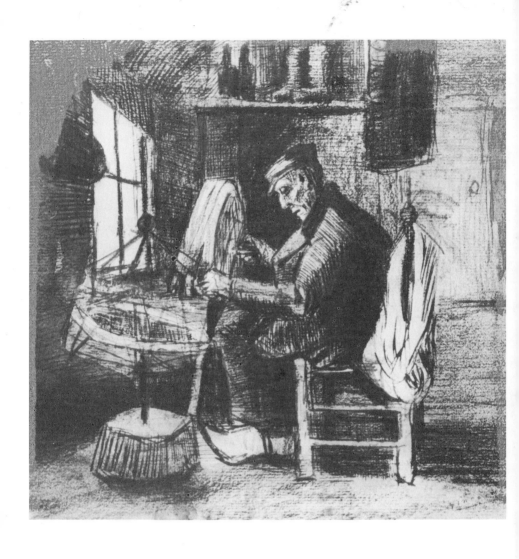

37
Woman Winding Bobbins

April 1884, Nuenen
Gouache, 33 × 44 cm (F 1139)
Wildenstein Art Gallery, New York

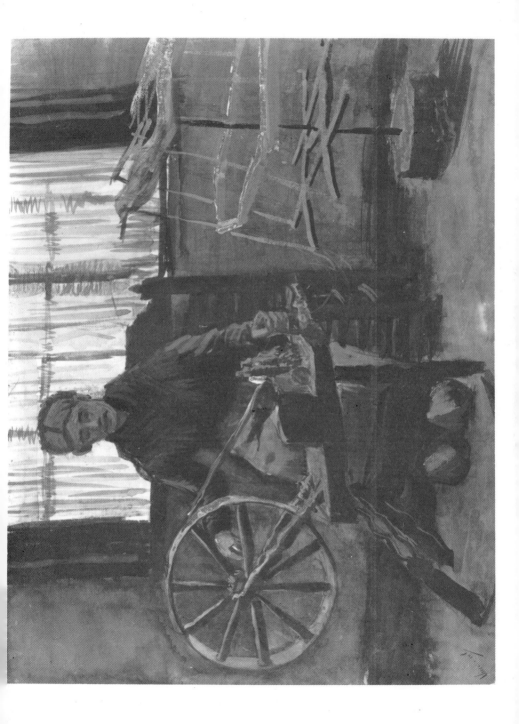

38

Alley of Willows with Shepherd and Peasant Woman

Spring 1884, Nuenen
Pencil and pen, 39.5 × 54.5 cm (F 1240)
Vincent van Gogh Museum, Amsterdam

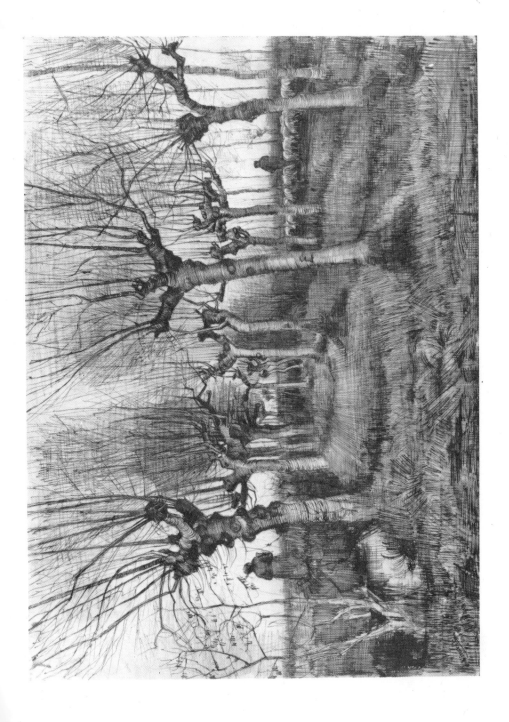

39
Peasant Woman with White Cap, Seated

December 1884 or shortly after, Nuenen
Pencil, pen, and brown ink, 32 × 20.5 cm (F 1189)
Vincent van Gogh Museum, Amsterdam

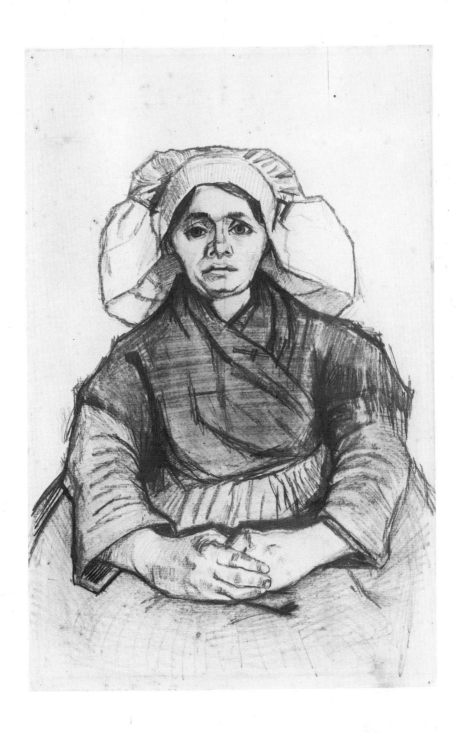

40

Head of a Peasant Woman

May-June 1885, Nuenen
Black chalk, 40 × 33 cm (F 1182)
Vincent van Gogh Museum, Amsterdam

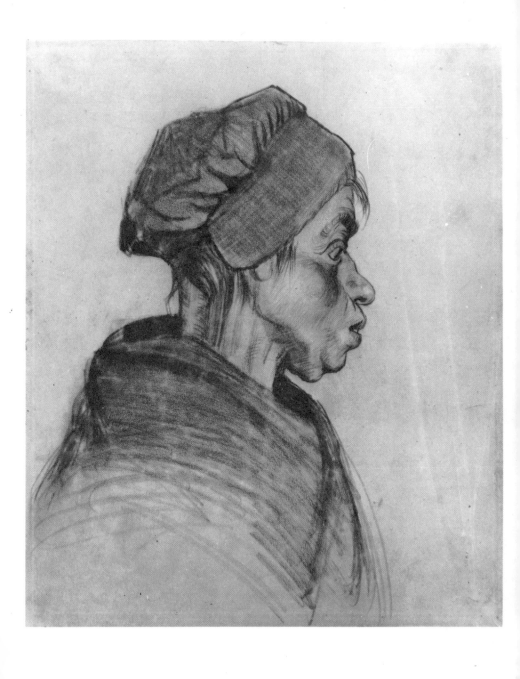

41

Public Sale of Crosses at the Nuenen Cemetery

May 1885, Nuenen
Watercolor, 37.5 × 55 cm (F 1230)
Vincent van Gogh Museum, Amsterdam

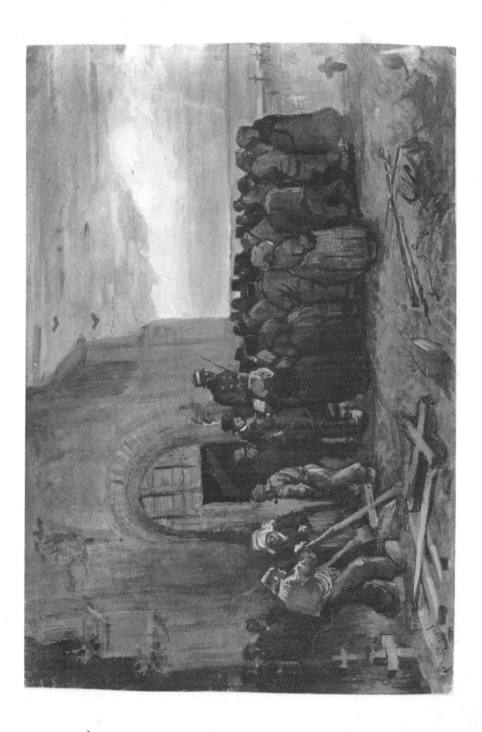

42

Hand Clasping a Stick; Interior with Four Persons

April 1885 or shortly afterwards, Nuenen
Black chalk, 42 × 34.5 cm (F 1168 recto)
Vincent van Gogh Museum, Amsterdam

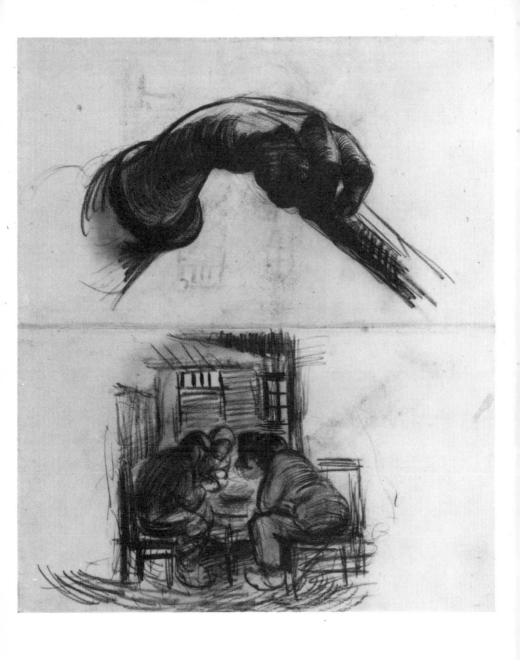

43
The Potato Eaters

Mid-April 1885, Nuenen
Lithograph, 26.5 × 30.5 cm (F 1661)
Vincent van Gogh Museum, Amsterdam

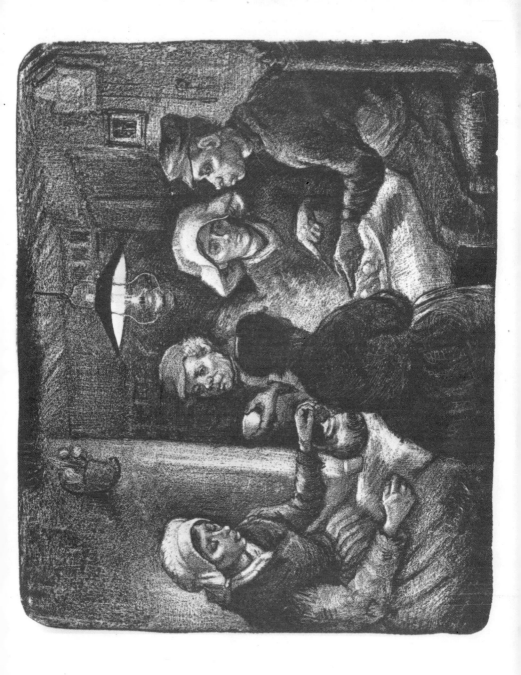

44

Two Isolated Trees under Storm Clouds, with Windmill in the Background

Summer 1885, Nuenen
Black chalk, stumped, heightened with white, 29 × 22.5 cm (F 1346)
Vincent van Gogh Museum, Amsterdam

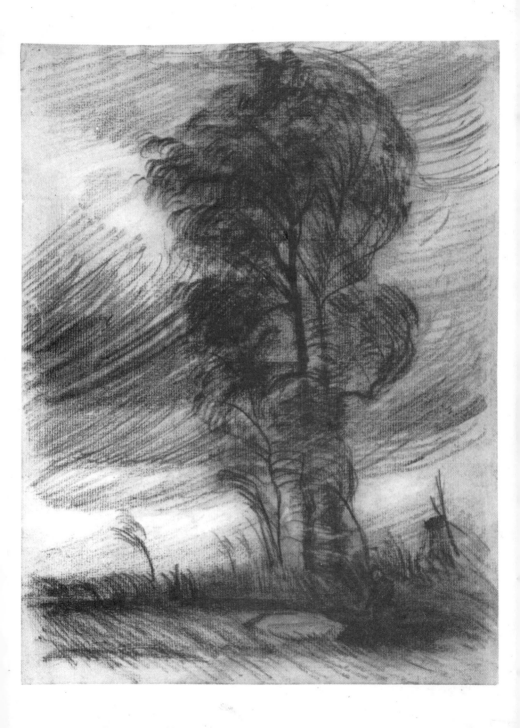

45

Reaper with Cap

August 1885, Nuenen
Black chalk, stumped, 43 × 55 cm (F 1317)
Vincent van Gogh Museum, Amsterdam

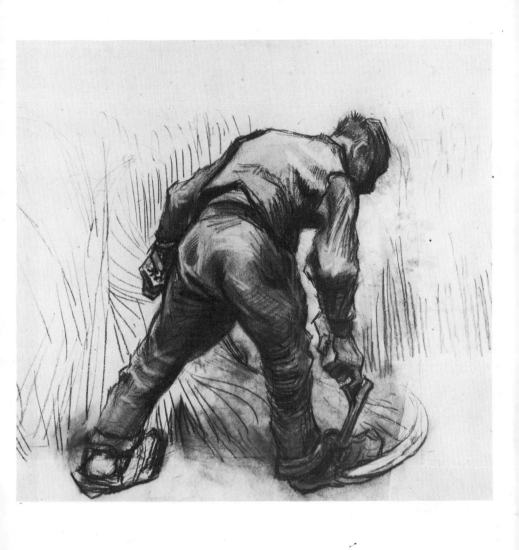

46
Woodcutter

Fall 1885, Nuenen
Black chalk, stumped, 44 × 54.5 cm (F 1327)
Vincent van Gogh Museum, Amsterdam

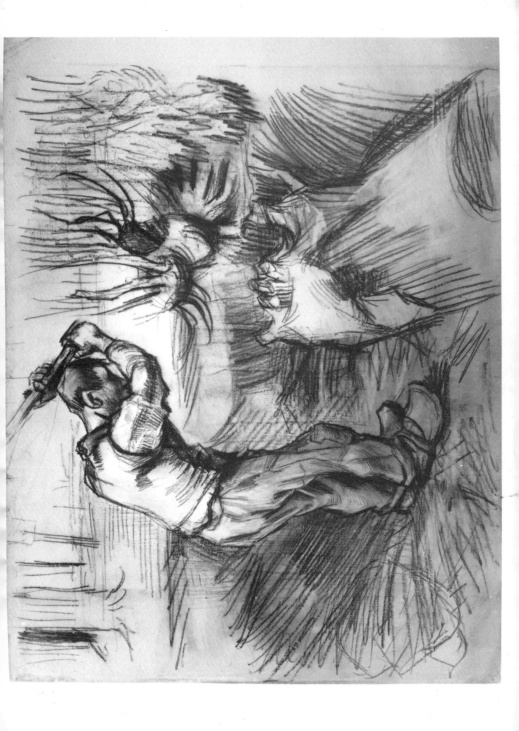

47
Peasant Woman Binding Wheat

August 1885, Nuenen
Black chalk, washed, 45 × 53 cm (F 1264)
Kröller-Müller Museum, Otterlo

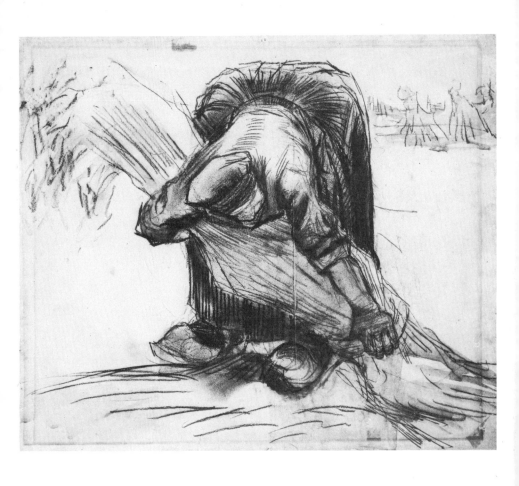

48

Peasant Working, with Two Cottages in the Background

Probably fall 1885, Nuenen
Black chalk, stumped, 44 × 33.5 cm (F 1325)
Kröller-Müller Museum, Otterlo

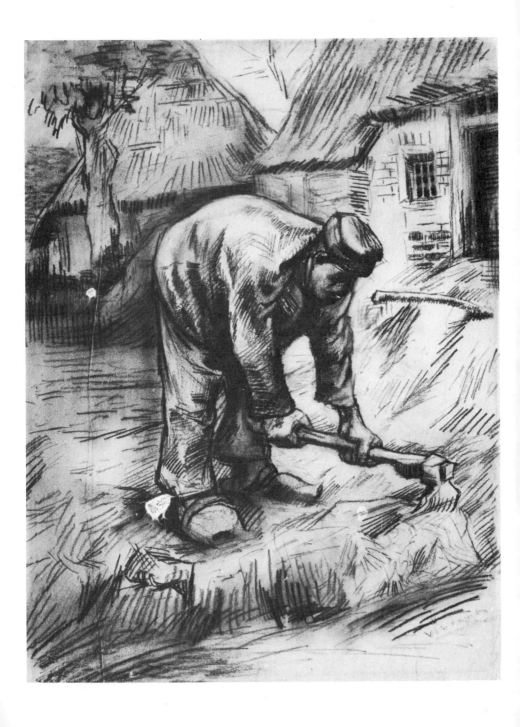

49
Interior with a Peasant Woman Making Pancakes

Second half of 1885, Nuenen
Black chalk, heightened with white, 29 × 35.5 cm (F 1215)
Vincent van Gogh Museum, Amsterdam

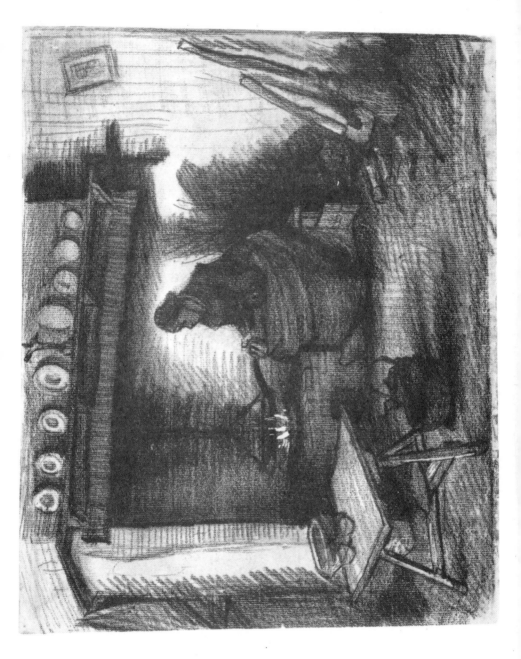

50
The Grote Markt in Antwerp

December 18, 1885, Antwerp
Black chalk, heightened with colors, 22.5 × 30 cm (F 1352)
Vincent van Gogh Museum, Amsterdam

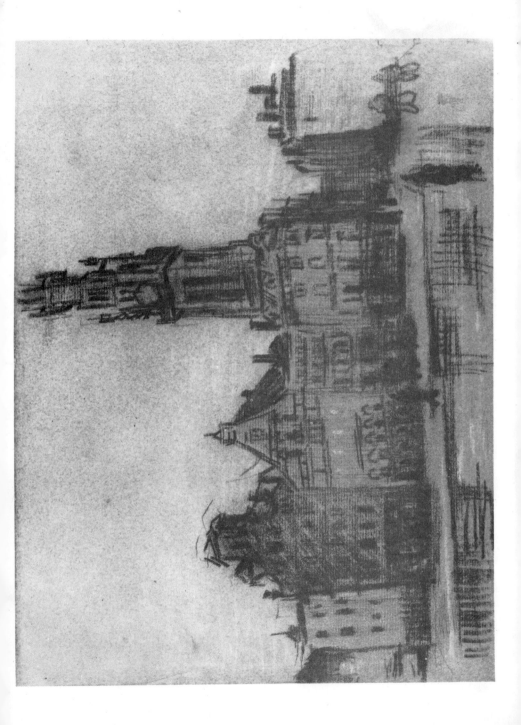

51

Spire of the Church of Our Lady in Antwerp

December 18, 1885, Antwerp
Black chalk on pink paper, 30 × 22.5 cm (F 1356)
Vincent van Gogh Museum, Amsterdam

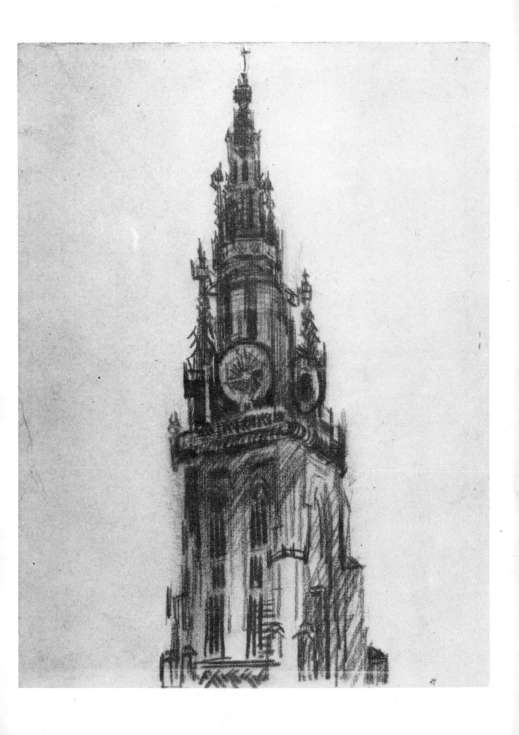

52

The Steen in Antwerp

December 1885, Antwerp
Black and colored chalk, 9.3×16.4 cm (F 1350 recto)
Vincent van Gogh Museum, Amsterdam

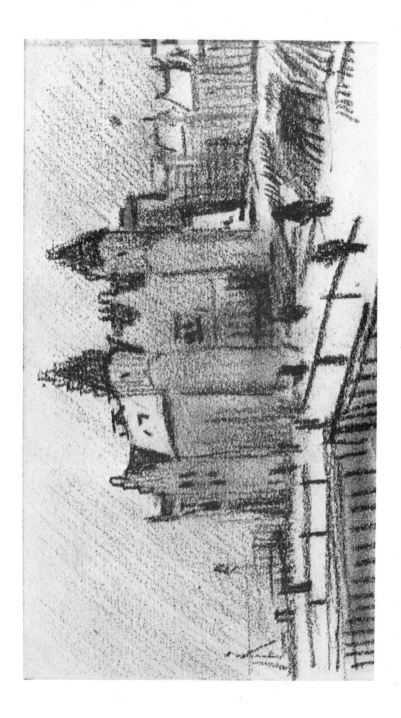

53
Women Dancing

Early December 1885, Antwerp
Black and colored chalk, 9.3 × 16.4 cm (F 1350b)
Vincent van Gogh Museum, Amsterdam

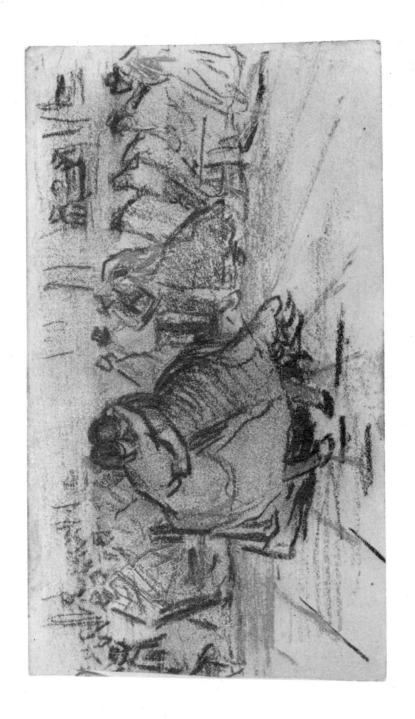

54

Five Studies of a Nude Girl, Seated

Early 1886, Paris
Black chalk, 47.5 × 61.5 cm (F 1366 recto)
Vincent van Gogh Museum, Amsterdam

55
Nude Girl Sitting

Early 1886, Paris
Black chalk, 30.5 × 23.5 cm (F 1367)
Vincent van Gogh Museum, Amsterdam

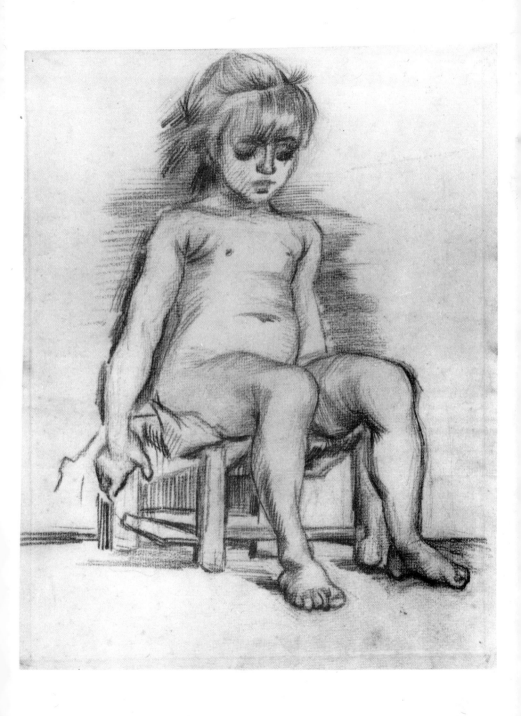

56
Café La Guinguette

October 1886, Paris
Pen and pencil, heightened with white, 37.9 × 52.3 cm (F 1407)
Vincent van Gogh Museum, Amsterdam

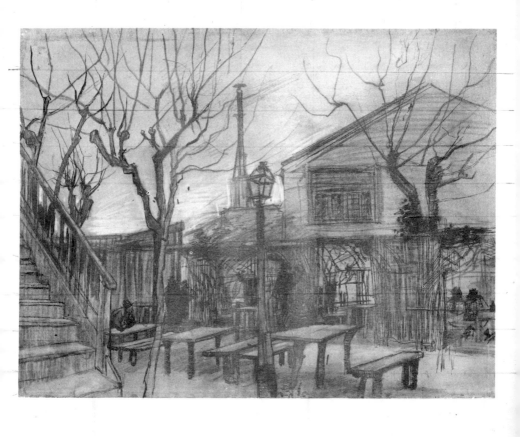

57

Two Self-portraits; Fragments of Others

Summer 1887, Paris
Pen, pencil, ink, 31.6 × 24.1 cm (F 1378 recto)
Vincent van Gogh Museum, Amsterdam

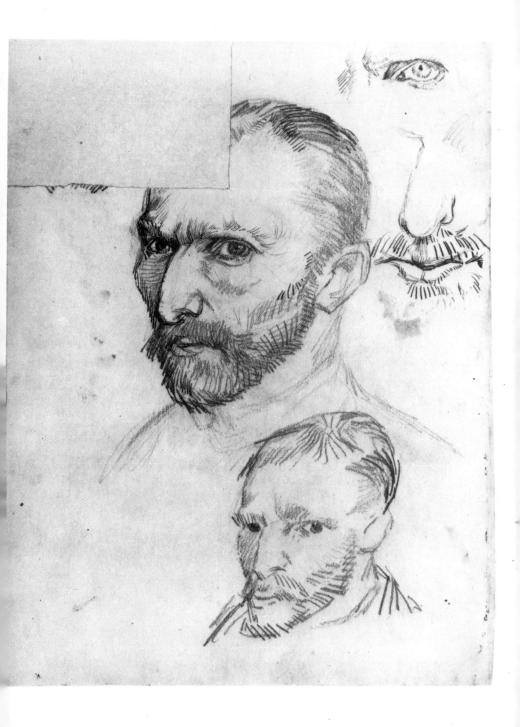

58
Boulevard de Clichy

February-March 1887, Paris
Pen, blue, pink and white crayon, 39.8 × 54 cm (F 1393)
Vincent van Gogh Museum, Amsterdam

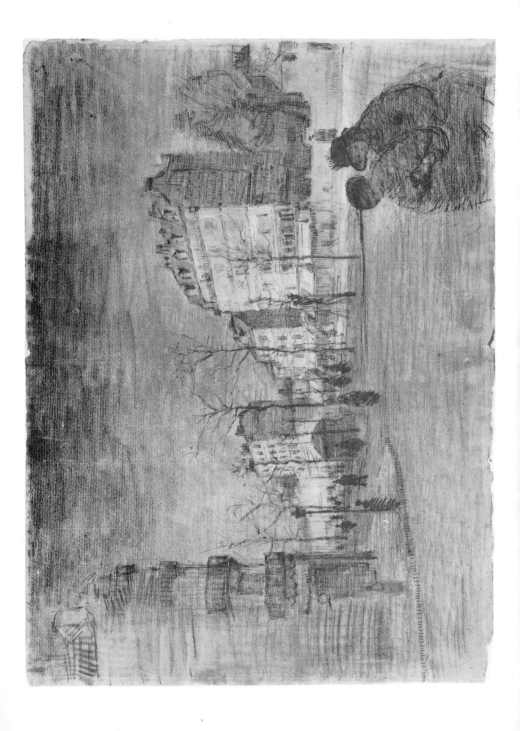

59
View from Vincent's Room in the Rue Lepic

February-March 1887, Paris
Pencil and pen, washed, 39.5 × 53.5 cm (F 1391)
Vincent van Gogh Museum, Amsterdam

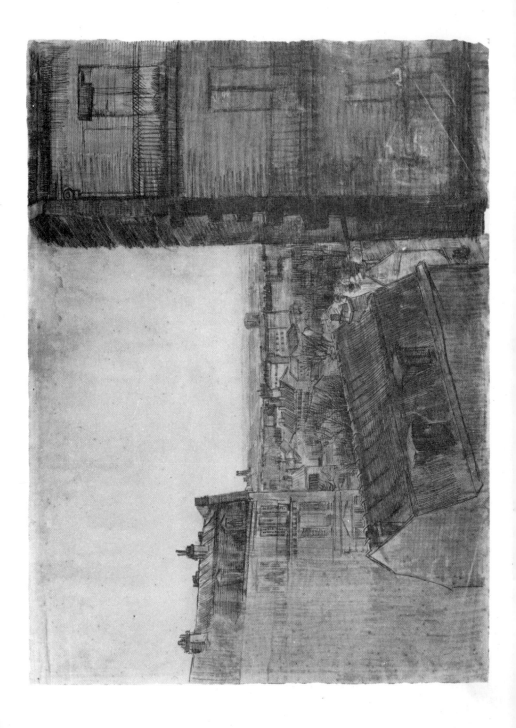

60

Shelter on the Hill of Montmartre, with Sunflowers

Late summer 1887, Paris
Pencil, pen, and blue and green watercolor, 30.5 × 23.9 cm (F 1411)
Vincent van Gogh Museum, Amsterdam

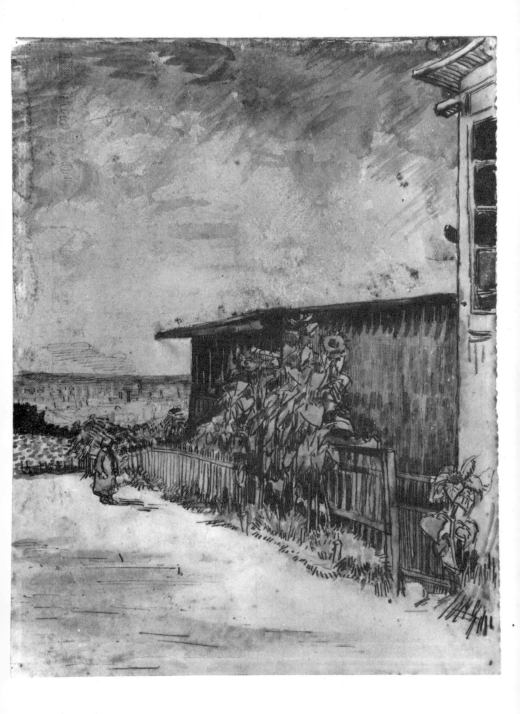

View of Roofs with the Tower of Saint-Julien at Arles

Early spring 1888, Arles
Pencil, reed pen and ink, 25.5 × 34.5 cm (F 1480a)
Galerie Berggruen, Paris

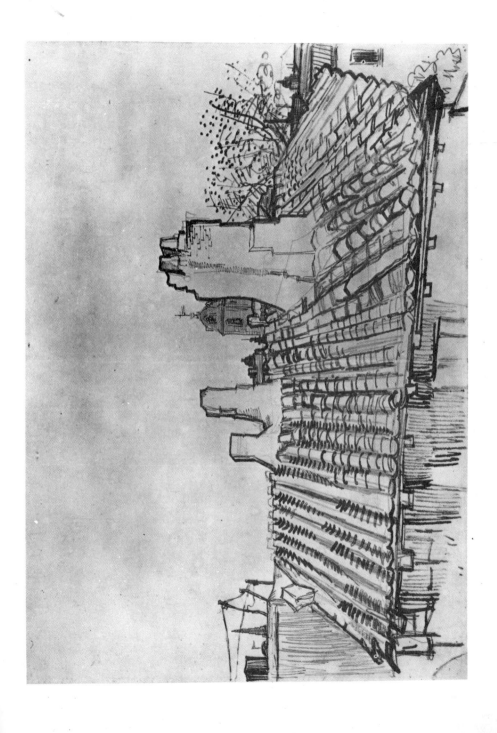

62

Orchard in Provence

April 1888, Arles
Reed pen, heightened with white, 39.5×54 cm (F 1414)
Vincent van Gogh Museum, Amsterdam

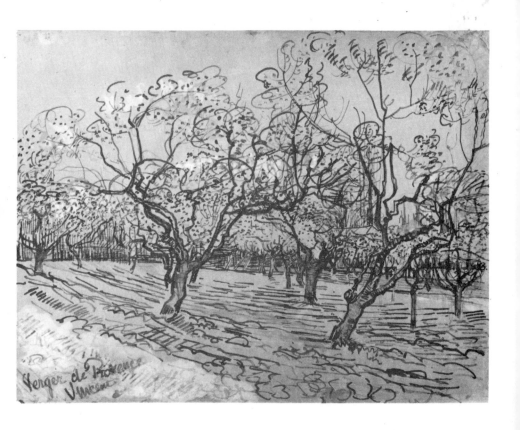

Verger de Provence
Vincent

63
Farmhouse in a Wheatfield

Early May 1888, Arles
Pencil, pen and reed pen, brown ink, 25.5 × 34.5 cm (F 1415)
Vincent van Gogh Museum, Amsterdam

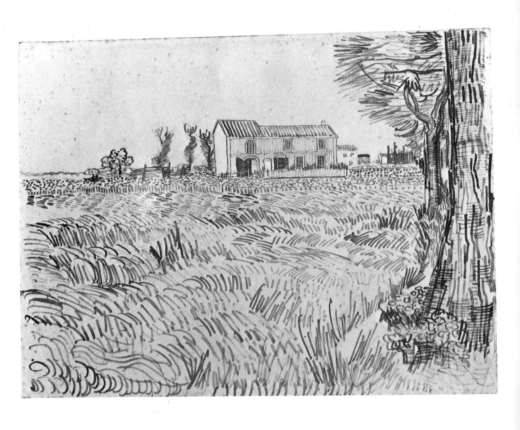

64

View of Saintes-Maries with Church and Ramparts

June 1888, Saintes-Maries
Reed pen and ink, 43×60 cm (F 1439)
Oskar Reinhart Collection, Winterthur

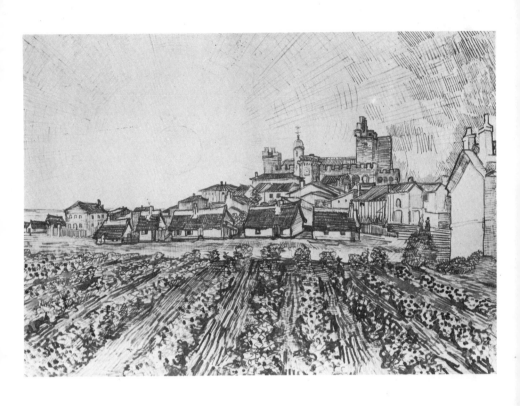

65

Street in Saintes-Maries

June 1888, Saintes-Maries
Reed pen and ink, 24 × 31 cm (F 1435)
Museum of Modern Art, New York; Abby Aldrich Rockefeller Bequest

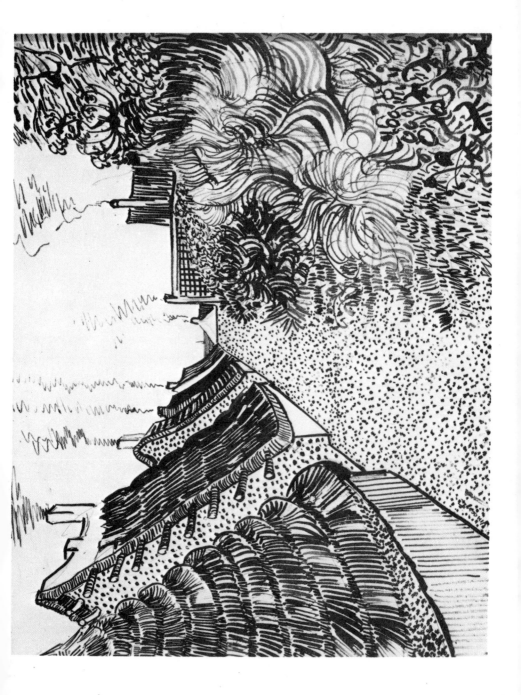

66

Sail-boats Coming Ashore

June 1888, Saintes-Maries
Reed pen and ink, 24.5 × 32 cm (F 1430a)
The Solomon R. Guggenheim Museum, New York; J. K. Thannhauser Foundation

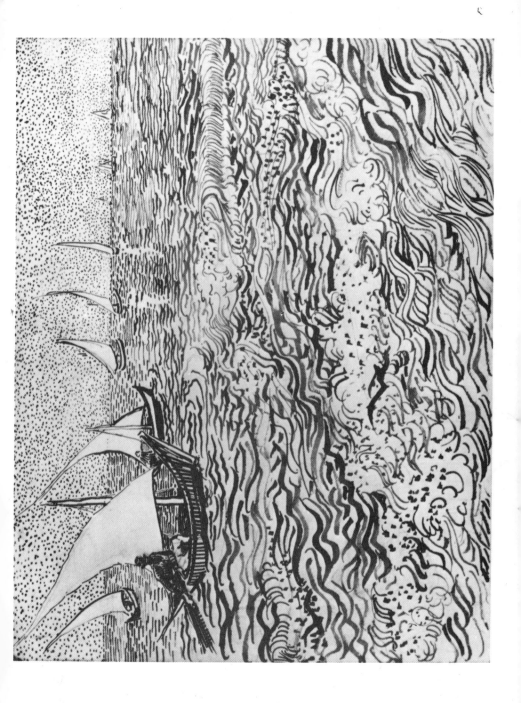

67

A Country Estate in Provence

June 1888, Arles
Pencil, reed pen and brown ink, 39 × 53.5 cm (F 1478)
Vincent van Gogh Museum, Amsterdam, on loan from the Rijksmuseum

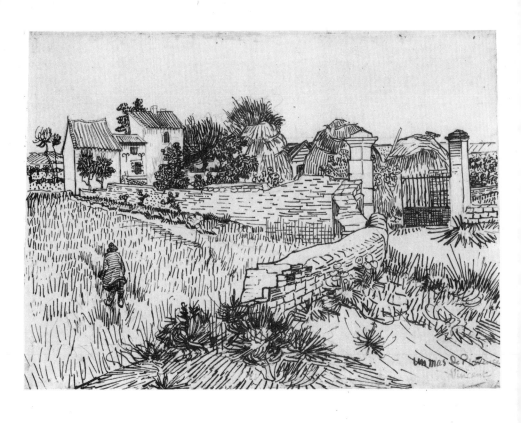

68

Montmajour

July 1888, Arles
Pen and ink, 47.5 × 59 cm (F 1446)
Rijksmuseum, Amsterdam

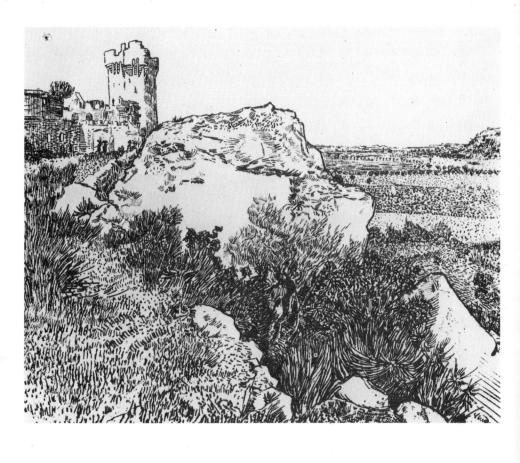

69

Landscape near Montmajour, with the Little Train from Arles to Orgon

Mid-July 1888, Arles
Pen, reed pen, and black chalk, 49 × 61 cm (F 1424)
The British Museum, London; The César Mange de Hauke Bequest

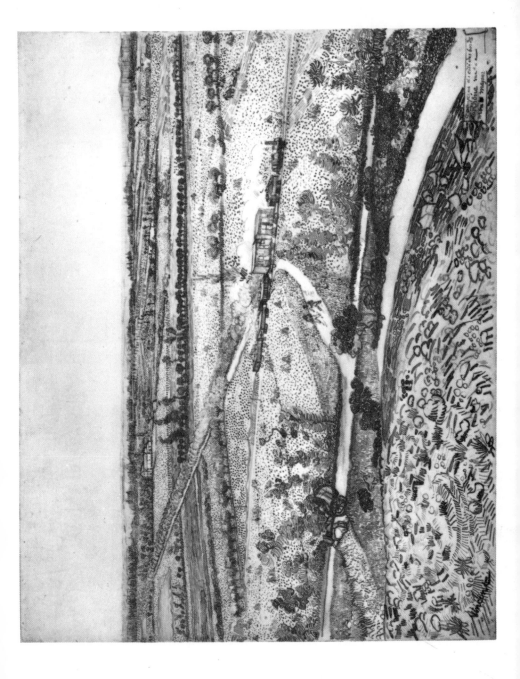

70

The Rock, Montmajour

July 1888, Arles
Pencil, reed pen, brush and black ink, 49×60 cm (F 1447)
Vincent van Gogh Museum, Amsterdam

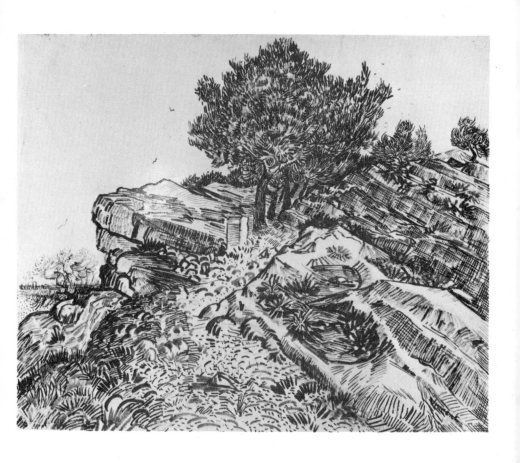

Portrait of Patience Escalier

August 1888, Arles
Pencil, pen, reed pen and brown ink, 49.5 × 38 cm (F 1460)
Fogg Art Museum, Cambridge, Massachusetts; Grenville L. Winthrop Bequest

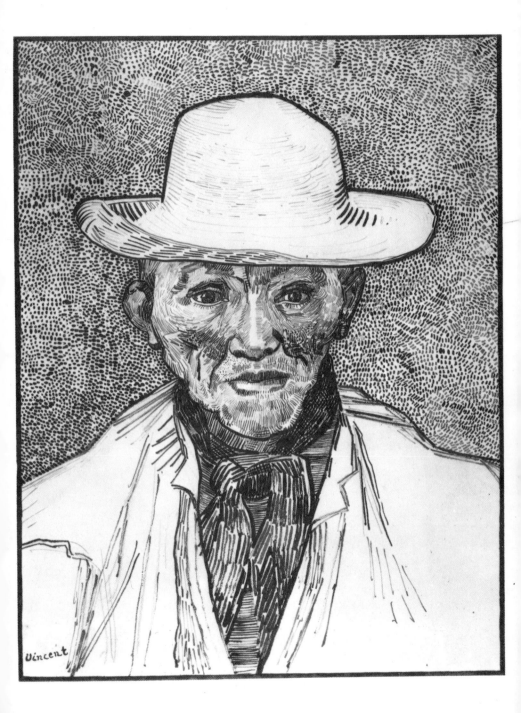

72

The Flowering Tree

March 1888, Arles
Charcoal and watercolor, 45.5 × 30.5 cm (F 1469)
Vincent van Gogh Museum, Amsterdam

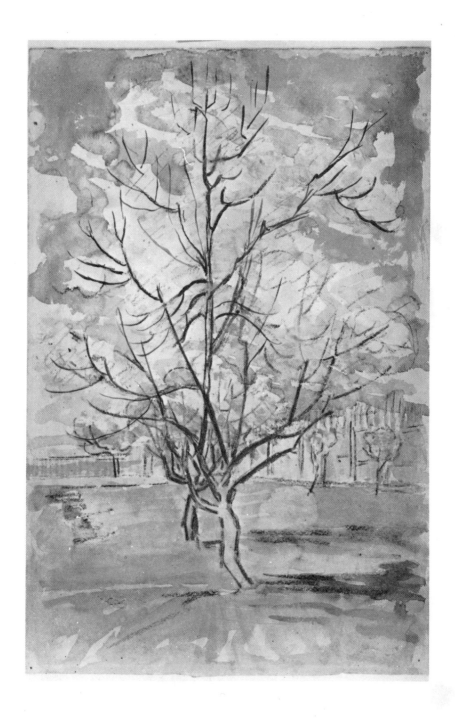

73

Road with Trees near a House

June 1888, Arles
Pencil, reed pen and brown ink, 24×34 cm (F 1518a)
Albertina, Vienna

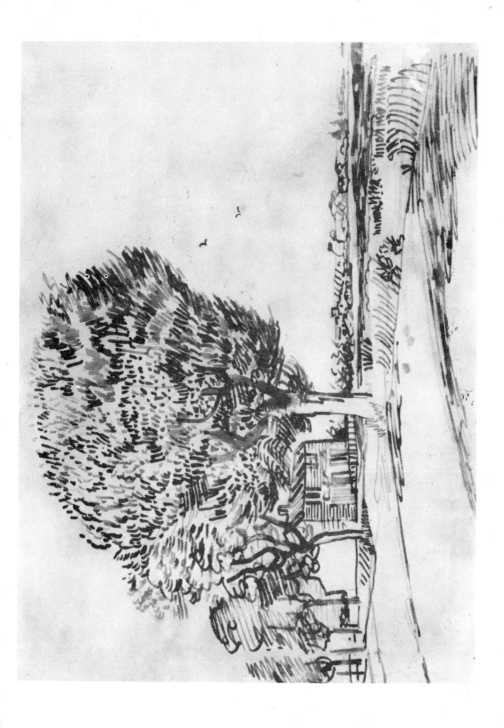

74

Sheaves in a Field

Summer 1888, Arles
Black chalk, brush and thin black ink, 47.5×62.5 cm (F 1641)
Vincent van Gogh Museum, Amsterdam

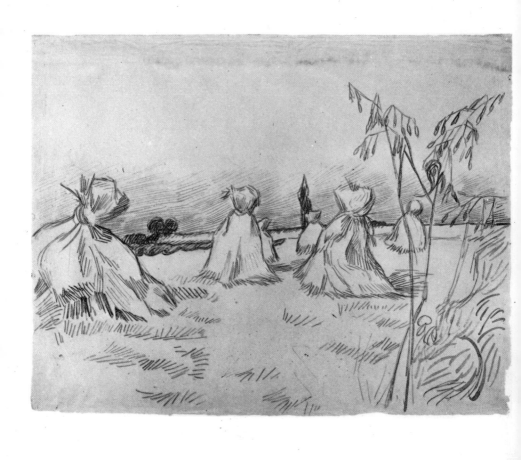

75

The Road to Tarascon

August 1888, Arles
Pencil, pen, reed pen and ink, 25.7×35 cm (F 1502)
Kunsthaus, Zürich

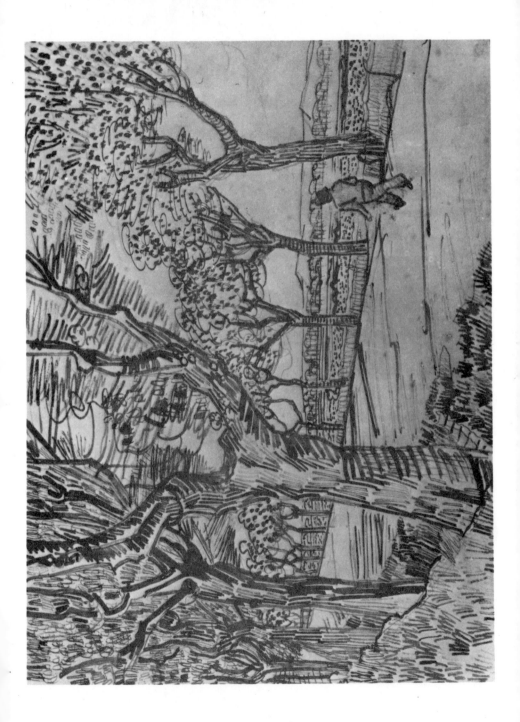

76

Road with Telegraph Pole and Crane

Summer 1888, Arles
Pencil, pen and ink, 24 × 32 cm (F 1495)
Vincent van Gogh Museum, Amsterdam

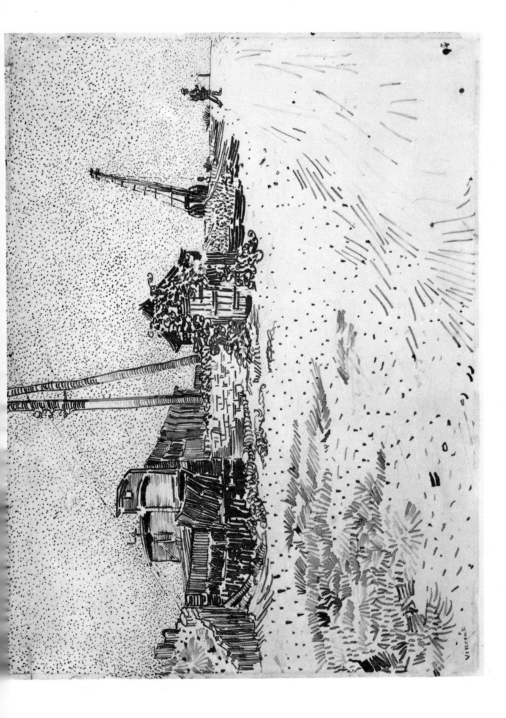

77

Park at Arles, with a Corner of the Yellow House

September 1888, Arles
Pen, reed pen and ink, 35 × 26 cm (F 1476)
Vincent van Gogh Museum, Amsterdam

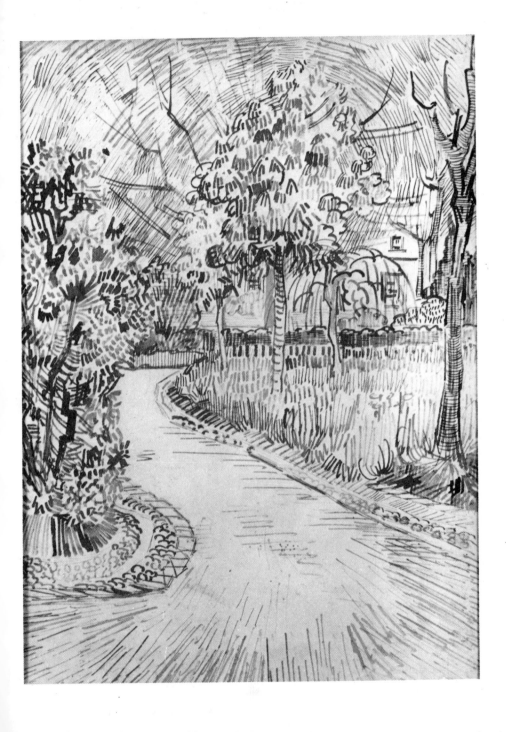

78

The Park Behind a Fence

September 1888, Arles
Pencil, pen and brown ink, 32 × 24.5 cm (F 1477)
Vincent van Gogh Museum, Amsterdam

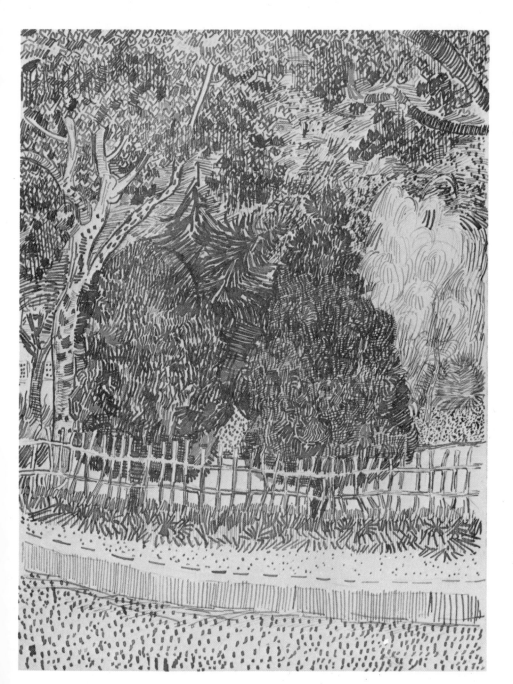

79

The Pond in the Park, with the Yellow House in the Background

September 1888, Arles
Pencil, reed pen and brown ink, 31.5 × 49.5 cm (F 1513)
Vincent van Gogh Museum, Amsterdam

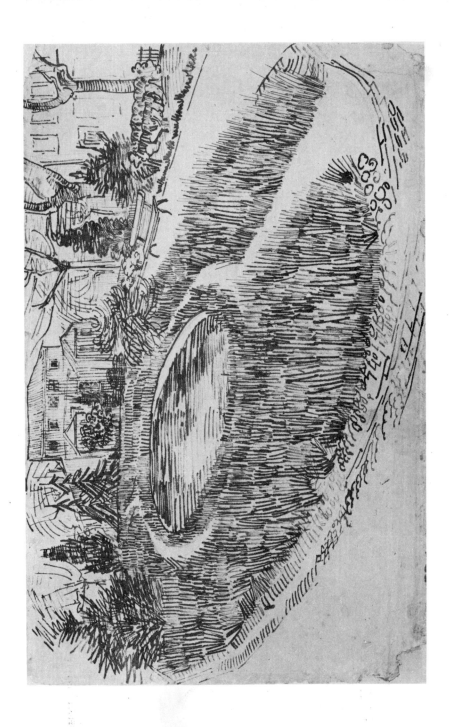

80

The Sower

November 1888, Arles
Sketch in letter 558a

Est ce qu'ils ont lu le livre de Silvestre sur Eug Delacroix ainsi que l'article sur la <u>couleur</u> dans la grammaire des arts du dessin de Ch. Blanc.
Demandes leur donc cela de ma part et sinon s'ils n'ont pas lu cela qu'ils le lisent. J'épense moi à Rembrandt plus qu'il ne peut paraître dans mes études.

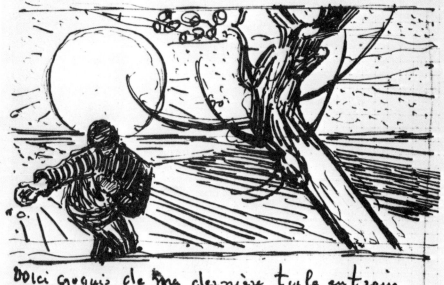

Voici croquis de ma dernière toile en train encore in demeure. Immense disque citron comme soleil. Ciel vert jaune à nuages roses. le terrain violet le semeur et l'arbre bleu de prusse, toile de 30

81

Breton Women in the Square of Pont-Aven (after Emile Bernard)

October-December 1888, Arles
Watercolor, 47.5 × 62 cm (F 1422)
Civica Galleria d'Arte Moderna, Milan; Grassi Collection

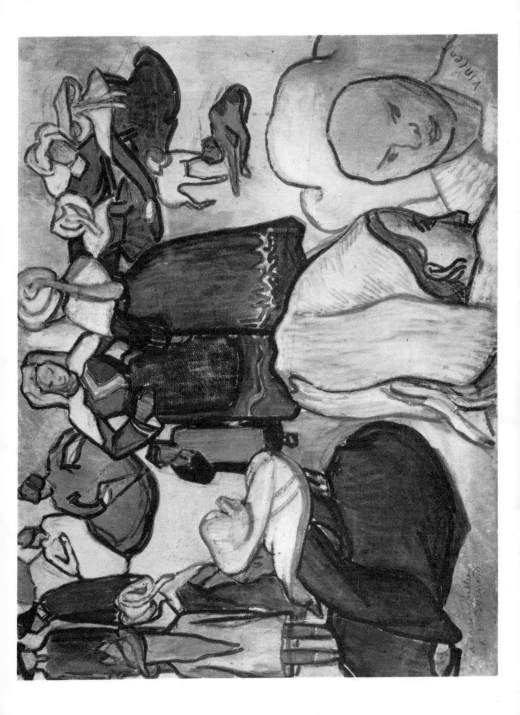

82

The Fountain in the Garden of the Hospital of Saint-Paul

May-early June 1889, Saint-Rémy
Black chalk, pen, reed pen and brown ink, 49.5 × 46 cm (F 1531)
Vincent van Gogh Museum, Amsterdam

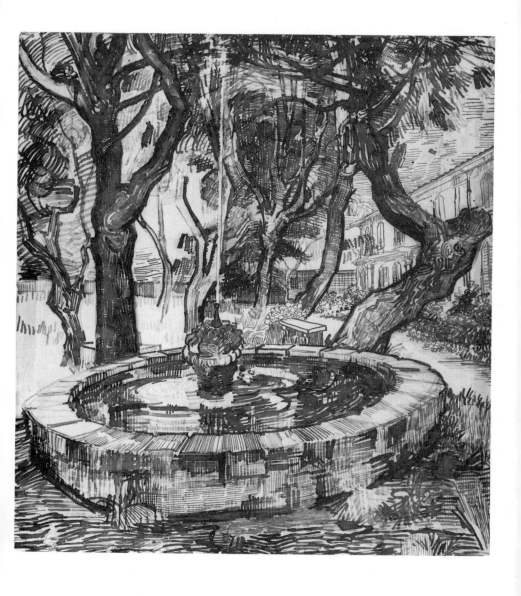

83

Tree with Ivy and a Stone Bench in the Garden of the Hospital of Saint-Paul

May 1889, Saint-Rémy
Pencil, reed pen and brown ink, 62 × 47 cm (F 1522)
Vincent van Gogh Museum, Amsterdam

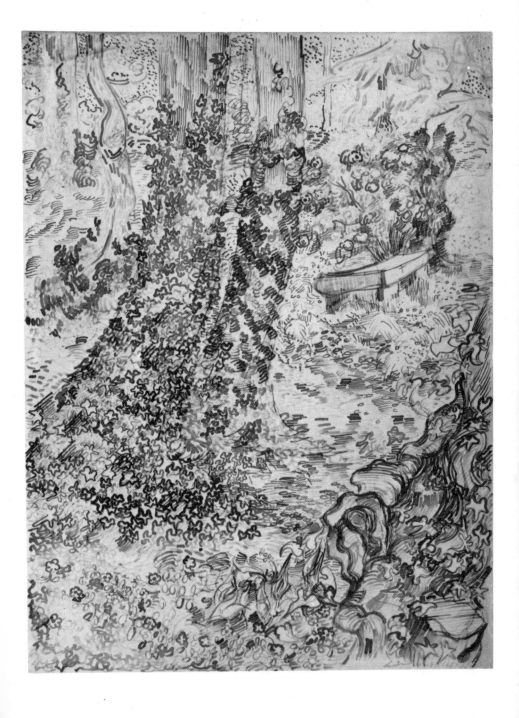

84

Tree with Ivy in the Garden of the Hospital of Saint-Paul

July 1889, Saint-Rémy
Pencil, reed pen, brush and brown ink, 60.5 × 47 cm (F 1532)
Vincent van Gogh Museum, Amsterdam

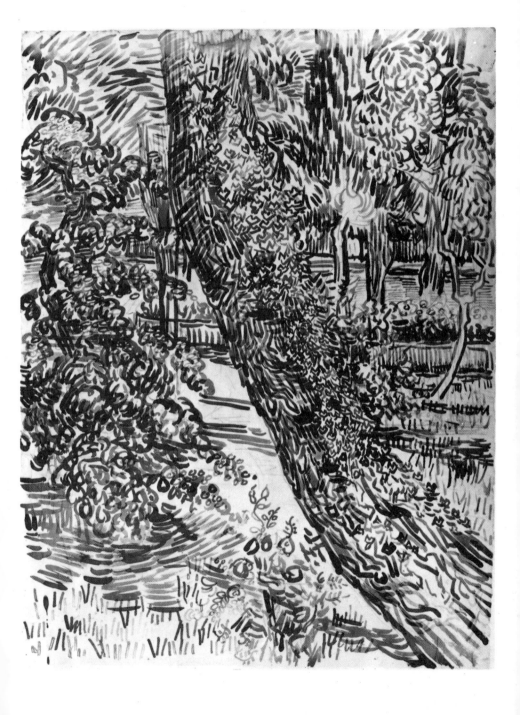

Cypresses, with Two Women in the Foreground

June 1889, Saint-Rémy
Black chalk, reed pen and ink, 31 × 23 cm (F 1525a)
Kröller-Müller Museum, Otterlo

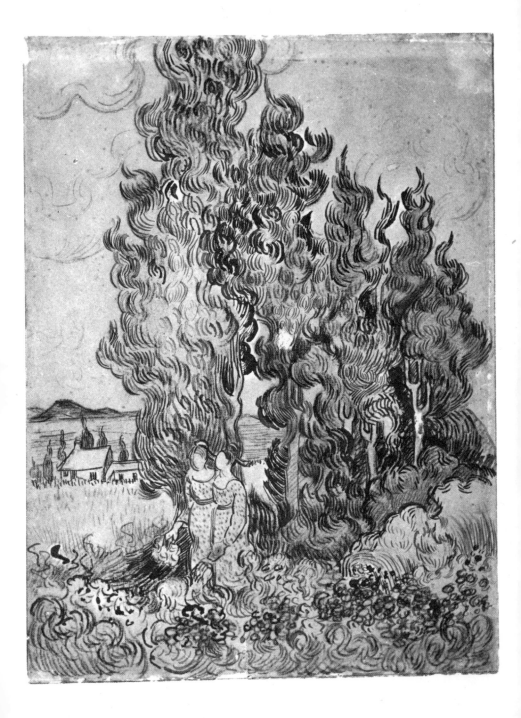

86

Starry Night with Cypresses

June 1889, Saint-Rémy
Pen and ink, 47×62.5 cm (F 1540)
This drawing was lost during World War II; formetly in Kunsthalle, Bremen

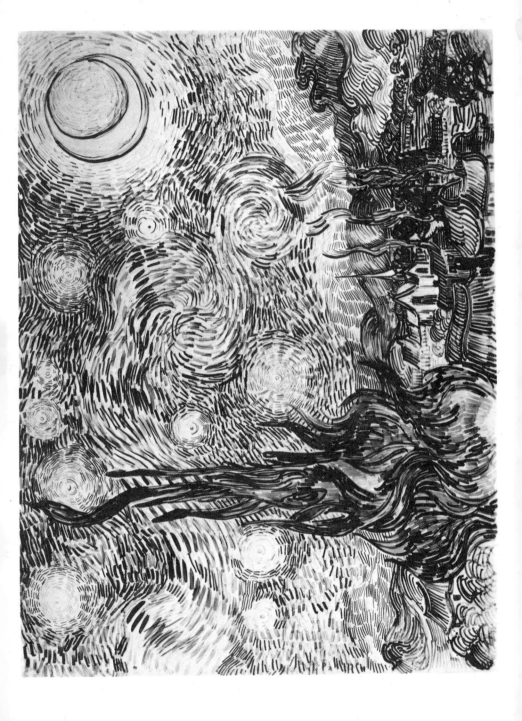

87

Corner of the Enclosure Behind the Hospital of Saint-Paul

May-June 1889, Saint-Rémy
Pencil and black chalk, 25 × 32.5 cm (F1557)
Vincent van Gogh Museum, Amsterdam

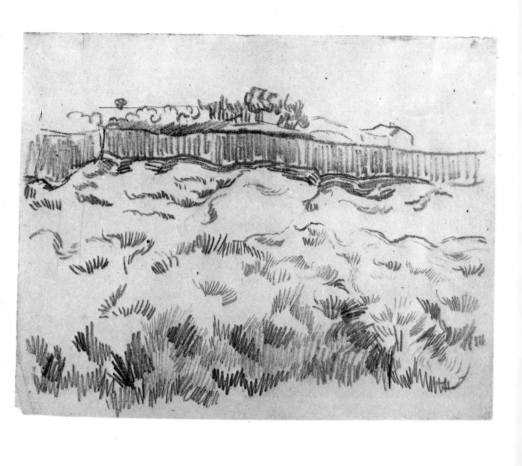

88

Road with Pine Trees

May-fall 1889, Saint-Rémy
Black chalk, stumped, 25 × 32.5 cm (F 1569)
Vincent van Gogh Museum, Amsterdam

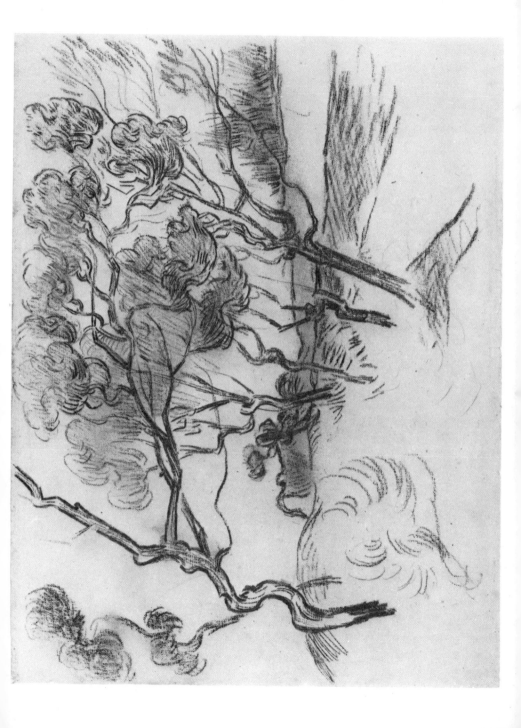

89

Dead Tree in the Garden of the Hospital of Saint-Paul

May–October 1889, Saint-Rémy
Pencil, 30 × 16.5 cm (F 1567 recto)
Vincent van Gogh Museum, Amsterdam

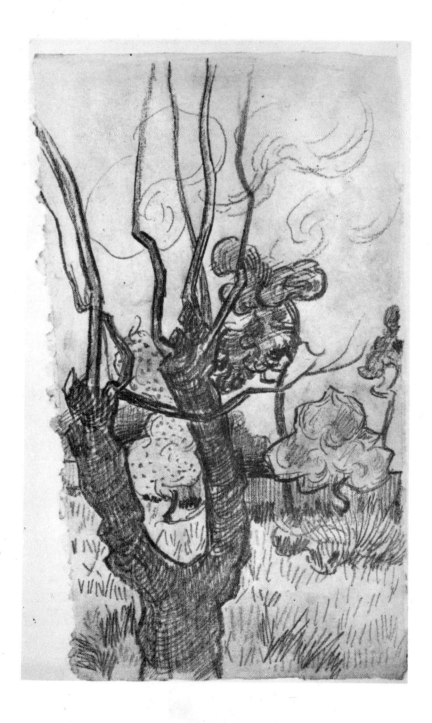

90
Landscape with Trees

Fall 1889, Saint-Rémy
Pencil, reed pen and ink, 47×60 cm (F 1501)
Vincent van Gogh Museum, Amsterdam

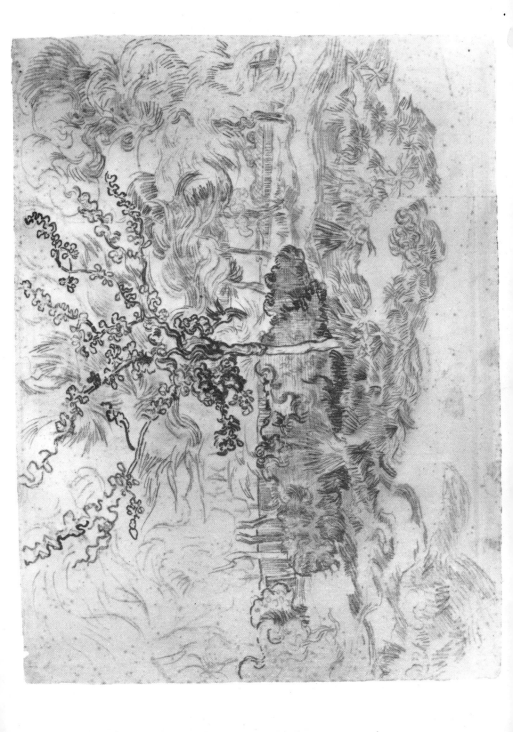

91
Wheatfield Seen from the Window of Vincent's Room at the Hospital of Saint-Paul

Fall 1889, Saint-Rémy
Black chalk, pen and brown ink, heightened with white and black chalk, 47.5 × 56 cm (SD 1728)
Kröller-Müller Museum, Otterlo

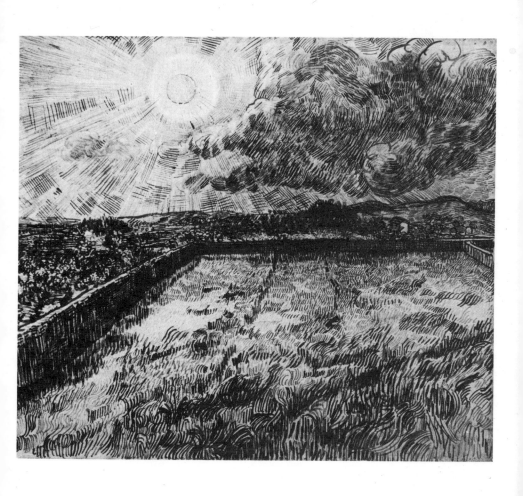

92

Interior of a Farmhouse with Two Peasants at a Table

January-April 1890, Saint-Rémy
Pencil, 24.5 × 32 cm (F 1585 verso)
Vincent van Gogh Museum, Amsterdam

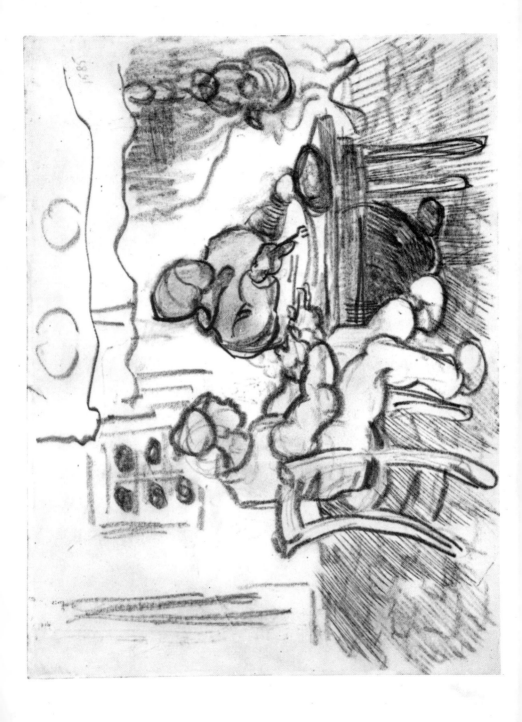

93
Peasant Digging

Spring 1890, Saint-Rémy
Black chalk, 28.5 × 23.5 cm (F 1587 verso)
Vincent van Gogh Museum, Amsterdam

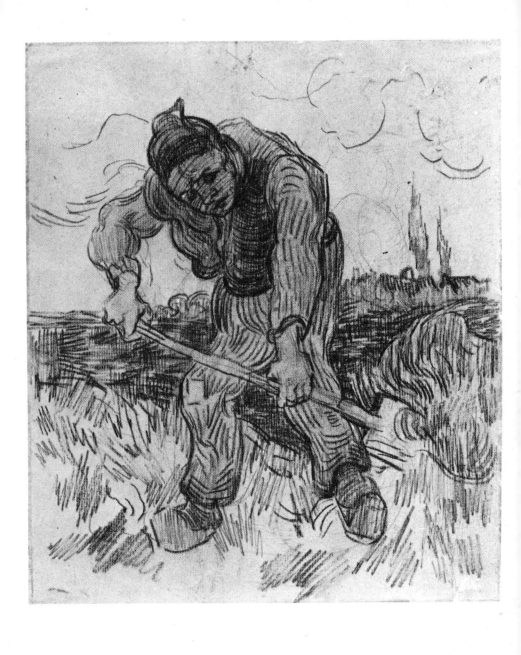

94

Portrait of Dr Gachet (The Man with the Pipe)

May 1890, Auvers
Etching, 18 × 15 cm (F 1664)
Vincent van Gogh Museum, Amsterdam

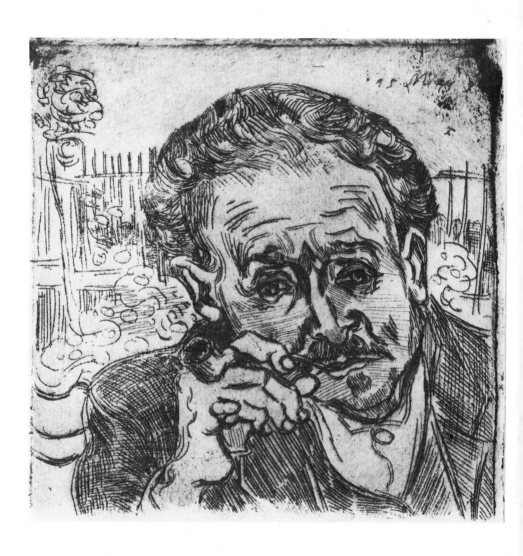

95

Street in Auvers, The House of Père Pilon

May–early June 1890, Auvers
Pencil, pen and brown ink, 44.5 × 55 cm (F 1638 recto)
Vincent van Gogh Museum, Amsterdam

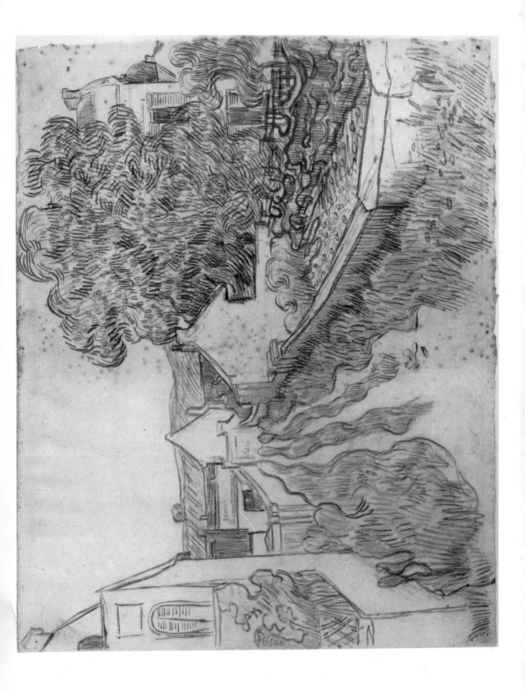

96
The Farm of Père Elois, with a Woman Working in the Foreground

June 1890, Auvers
Pencil, pen and ink, 47×61.5 cm (F 1653)
The Louvre, Paris; P. Gachet Bequest

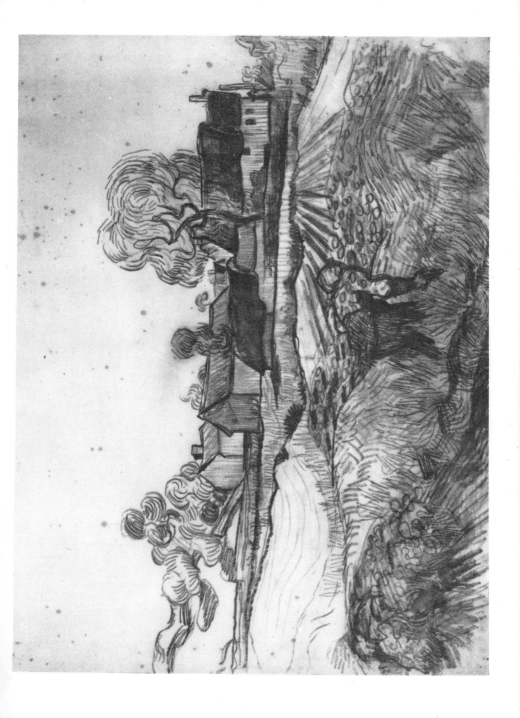

97

Mlle Gachet at the Small Organ; Landscape

July 1890, Auvers
Sketches in Letter 646

98
Man's Head; Perspective Frame

July 1890, Auvers
Sketches in blue chalk, 23.5 × 31 cm (F 1637 verso)
Vincent van Gogh Museum, Amsterdam

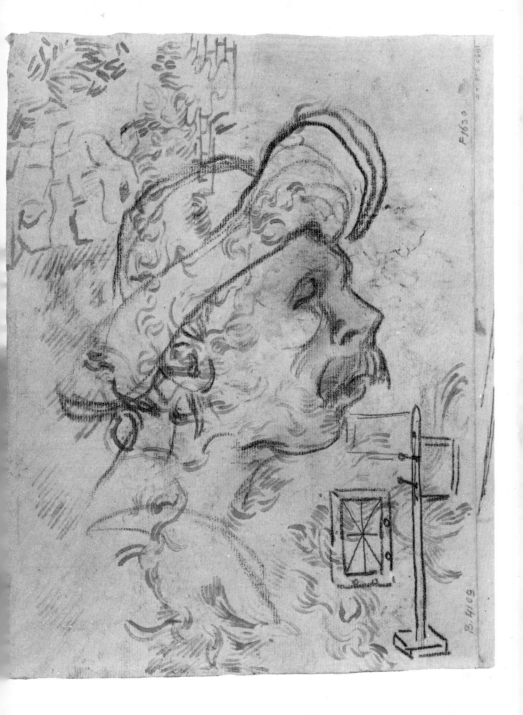

99
Study of Arum Lilies

May-June 1890, Auvers
Pen, reed pen and brown ink, 31 × 41 cm (F 1612)
Vincent van Gogh Museum, Amsterdam

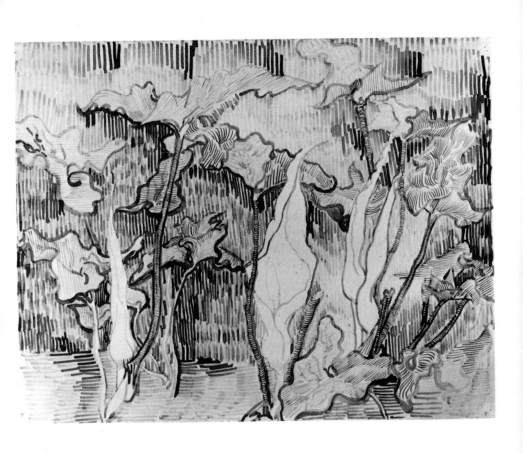

Branches of Feather Hyacinth (*Muscari commosum*)

May-June 1890, Auvers
Pencil, reed pen and brown ink, 41×31 cm (F 1612)
Vincent van Gogh Museum, Amsterdam

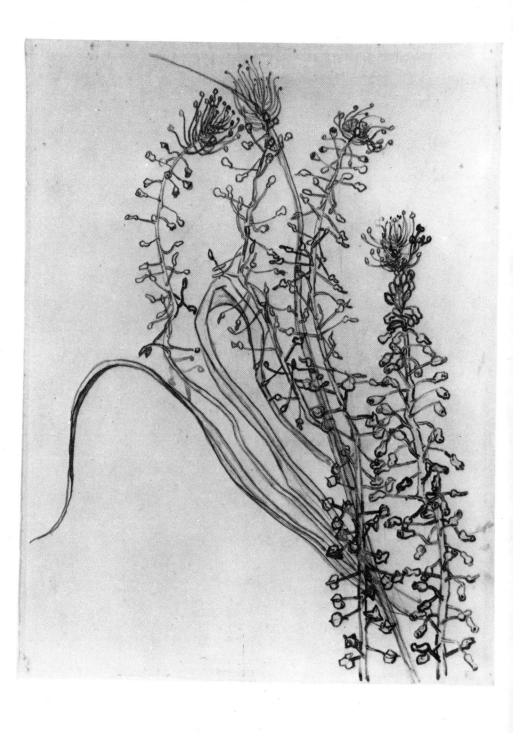

Select Bibliography

All the paintings and drawings of Vincent van Gogh are reproduced and described in the newly revised edition of J. B. de la Faille, *The Works of Vincent van Gogh: His Paintings and Drawings*. Meulenhoff, Amsterdam 1970, Weidenfeld and Nicolson, London 1970.

Vincent's letters to his brother Theo, his sister Wilhelmina, and the painters Anthon van Rappard and Emile Bernard, supplemented by other documents, were first published with an introduction by his sister-in-law, Johanna van Gogh-Bonger, in January 1914. This edition was augmented and expanded by Vincent's nephew, Dr V. W. van Gogh, in 1953 and was later reissued (7th printing, 1976) in cooperation with the Vincent van Gogh Foundation and the publishers 't Lanthuys and Wereldbibliotheek, Amsterdam/Antwerp. The major translation into English is the three-volume *Complete Letters of Vincent van Gogh*, Thames and Hudson, London 1958, and New York Graphic Society, Greenwich, Connecticut, 1953. Since most of the letters are not dated, the proper sequence is difficult to establish. A study of the correct chronology, with commentary on the letters, is *Van Gogh door Van Gogh: De brieven als commentaar op zijn werk*, arranged and annotated by Jan Hulsker, Meulenhoff, Amsterdam 1973.

Marc Edo Tralbaut, in his well-illustrated monograph, *Vincent van Gogh*, Macmillan, New York, London and Lausanne 1969, gives practically all the known facts of Vincent's life.

The literature concerning Vincent van Gogh is extensive, and any selection must remain arbitrary. The following studies are of exceptional value, however:
Carl Nordenfalk, *The Life and Work of Van Gogh* (translated from the Swedish by L. Wolfe), Philosophical Society, New York 1953.
Meyer Shapiro, *Vincent van Gogh*, Harry N. Abrams, New York 1950.
Bogomila Welsh-Ovcharov, *Vincent van Gogh: his Paris Period 1886-1888*, Utrecht/The Hague 1976.

Vincent van Gogh as draftsman is the subject of:
Julius Meier-Graefe, *Vincent van Gogh der Zeichner*, Otto-Wacker Verlag, Berlin 1928.
Douglas Cooper, *Drawings and Watercolors by Vincent van Gogh*, Macmillan, New York 1955.
W. Jos de Gruyter, *Tekeningen van Vincent van Gogh*, Stichting Openbaar Kunstbezit 1962
Anna Szymańska, *Unbekannte Jugendzeichnungen Vincent van Goghs und das Schaffen des Künstlers in den Jahren 1870-1880*, Henschelverlag, Berlin 1967.

Concerning the artistic environment in which Vincent's work was created, the books by John Rewald remain the best source, in particular his *Post-Impressionism from Van Gogh to Gauguin*, Museum of Modern Art, New York, 1st edn 1956, reprinted 1962.

Sources of the Illustrations

Amsterdam, Reproduction Department of the Stedelijk Museum: illustrations on pages 20, 22, 26, colorplates I, II, III, IV; plates 6, 10, 11, 12, 13, 14, 16, 17, 21, 22, 23, 24, 26, 27, 29, 32, 33, 34, 35, 38, 39, 40, 41, 42, 43, 44, 45, 46, 49, 50, 51, 52, 53, 54, 55, 56, 57, 58, 59, 60, 62, 63, 67, 70, 72, 74, 76, 77, 78, 80, 82, 83, 84, 86, 87, 88, 89, 90, 92, 93, 94, 95, 97, 98, 99, 100
Bilthoven, collection of the author: illustration on page 14
Cambridge, Massachusetts, Fogg Art Museum: plate 71
Cologne, Archiv DuMont Buchverlag: illustration on page 24; plates 64, 68
Groningen, Piet Boonstra: plate 28
London, The British Museum: plate 69
Milan, Archivio Fotografico dei Civici Musei; plate 81
New York, The Museum of Modern Art: plate 65
New York, The Solomon R. Guggenheim Museum: plate 66
New York, Wildenstein Gallery: plate 37
Otterlo, Kröller-Müller Museum: plates 1, 2, 3, 4, 5, 7, 8, 15, 18, 19, 20, 25, 30, 31, 36, 47, 48, 85, 91
Paris, Galerie Berggruen: plate 61
Paris, Service de documentation photographique de la réunion des Musées Nationaux: illustrations on pages 11, 30; plate 96
Utrecht, Centraal Museum: illustration on page 16; plate 9
Vienna, Lichtbildstätte Alpenland: plate 73
Zürich, Walter Dräyer: plate 75